Basics of
the New
Calligraphy

D1332252

MARGARET SHEPHERD

BASICS of the NEW CALLIGRAPHY

THORSONS

THORSONS PUBLISHING GROUP
Wellingborough, Northamptonshire

First published in the United Kingdom 1988

Originally published in the United States of America by Prentice Hall Press, a division of Simon & Schuster Inc., Gulf+Western Building, One Gulf+Western Plaza, New York, NY 10023

(Prentice Hall Press is a trademark of Simon & Schuster Inc.)

British Library Cataloguing in Publication Data

Shepherd, Margaret
 Basics of the new calligraphy
 1. Calligraphy
 I. Title
 745. 6'1 Z43

 ISBN 0-7225 1447-6

Printed in Great Britain

Published by Thorsons Publishers Limited, Wellingborough, Northamptonshire NN8 2RQ, England

10 9 8 7 6 5 4 3 2 1

CONTENTS

INTRODUCTION

There are many ways to approach the art of calligraphy: by copying the written alphabets of past centuries or by modifying & modernizing them; by developing one's own handwriting into a vehicle for personal expression; by adapting letters from other media (stone carved, brush painted, typeset) to the broad-edged pen; & by inventing original alphabets from scratch. I have used all of these approaches in my other books about calligraphy as an art, a craft, a historical specialty, a hobby, or a visual exercise. This book, however, offers the would-be calligrapher a completely new way to letter; the pen does the teaching.

All the alphabets in this book are based on two Basic Block alphabets. The 16 variations on these styles are of fundamental simplicity, yet they contain a wealth of alphabets that broaden the calligrapher's repertoire of styles while they deepen the grasp of basic pen skills. Each variation includes detailed instructions on handling a pen, illustrations that highlight the visual lesson, a master alphabet to copy and a guideline sheet to copy it onto, suggestions for everyday use, examples of practical projects, and a related "bonus" alphabet to stimulate further exploration.

Although this book is set up for the reader to self-teach or to teach others in a systematic fashion, the casual reader can skim it for specific ideas or for help with a particular project. It can also be combined with many other books and resources. The calligrapher who studies & tries out these variations on Basic Block will possess a powerful tool for approaching all other pen-written letters in the future.

MATERIALS

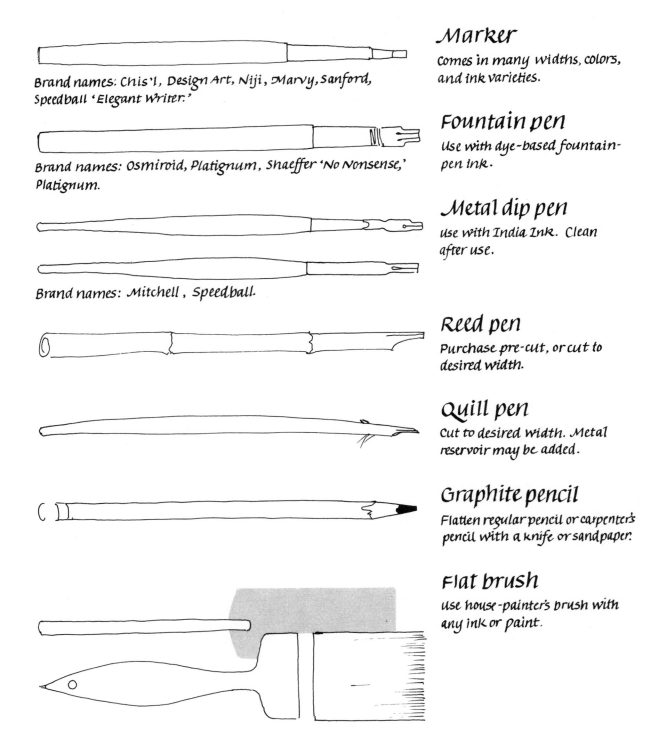

Brand names: Chis'l, Design Art, Niji, Marvy, Sanford, Speedball 'Elegant Writer.'

Brand names: Osmiroid, Platignum, Shaeffer 'No Nonsense,' Platignum.

Brand names: Mitchell , Speedball.

Marker
Comes in many widths, colors, and ink varieties.

Fountain pen
Use with dye-based fountain-pen ink.

Metal dip pen
Use with India Ink. Clean after use.

Reed pen
Purchase pre-cut, or cut to desired width.

Quill pen
Cut to desired width. Metal reservoir may be added.

Graphite pencil
Flatten regular pencil or carpenter's pencil with a knife or sandpaper.

Flat brush
Use house-painter's brush with any ink or paint.

DEFINITIONS

ASCENDER
Letter stroke that extends above the letter body.

DESCENDER
Letter stroke that extends below the letter body.

EXTENDER
Either an ascender or descender.

JOIN
Where two strokes intersect or touch.

LEFT & RIGHT
From the writer's, not the observer's, viewpoint.

LETTER HEIGHT

This is always expressed in terms of the width of the pen (see PEN WIDTH). It is measured by turning the pen sideways and lining up the recommended number of pen widths along a vertical line. Letters can be practiced at almost any size without affecting this ratio if the pen width also is varied accordingly, although an approximate size (e.g. large, medium) will be suggested, and, in general, large practice letters are best. You can eventually explore lighter & heavier pen widths than those shown.

NIB
The tip of the pen, that touches the paper.

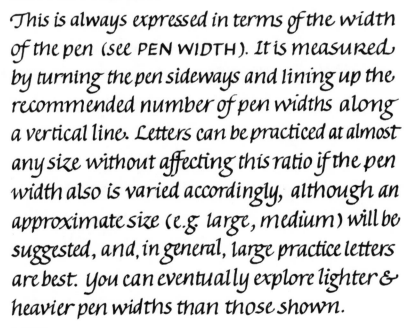

PEN
Can also refer to a wide-tipped brush or marker.

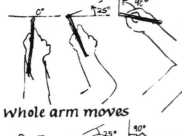

INCREASING PEN ANGLE

whole arm moves

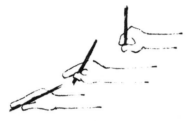

Pen only moves

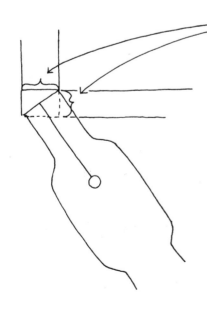

INCREASING PEN ELEVATION

PEN ANGLE

This is an imaginary angle made by the flat end of the pen nib and the horizontal baseline. You can enlarge this angle by moving your elbow farther from your body or by shifting the pen with your fingers, or by a combination of both. Every alphabet described here includes a recommendation about what pen angle to use .

PEN ELEVATION

This refers to how steeply the pen meets the paper surface. The steeper the elevation—in most cases —the greater the friction and the sharper the stroke. Several alphabets will require a steeper pen elevation than the rest; in general, however, each calligrapher will instinctively adjust the pen elevation to suit the pen, the paper, and the alphabet.

PEN UNIT

Either the width or height of a rectangle, of which the pen width forms the diagonal. This dimension will coincide with the weight of a vertical or horizontal stroke and will change if you change the pen size or pen angle. Differs from PEN WIDTH.

PEN WIDTH

The width of the broad nib. This is a useful dimension for gauging LETTER HEIGHT.

PROPORTION
The ratio between a letter's height and width.
SERIF
A mark that begins or ends a pen stroke.
SHAPE
The underlying structure of a group of letters:
round, half-round, arched. straight, diagonal.
SKATING
Pulling ink along with one corner of the pen.
STROKE DIRECTION
Direction in which the pen moves.
STROKE ORDER
The sequence of strokes in making a letter.
SWASH
A decorative stroke, one that is not essen-
tial to the letter's structure or identity.
THICK & THIN
Thick strokes are more than one-half pen
width wide, thin strokes are less.
TURNING
Changing pen angle during the stroke.

CAPITAL LETTERS

BASIC BLOCK letters seem so simple and familiar that many calligraphers are tempted to skip right over them without exploring their hidden potential. Both beginner and expert, however, can learn useful lessons from the construction of this alphabet, create dozens of variations, and then apply these techniques to any historical alphabet.

Block letters come from the classical Roman capitals, which are unsurpassed for their subtlety and elegance. If you are already familiar with the Roman alphabet, just simplify and streamline your usual approach. If block letters will be your first lesson in calligraphy, you can build on them if you want to try the more challenging Roman capitals later on.

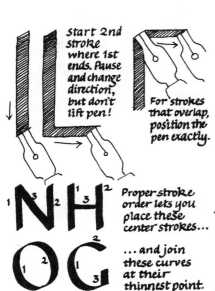

Start 2nd stroke where 1st ends. Pause and change direction, but don't lift pen!

For strokes that overlap, position the pen exactly.

Proper stroke order lets you place these center strokes...

...and join these curves at their thinnest point.

Half-round letters

Follow a few simple rules to give block letters the clarity and precision they need. First, keep the pen at one angle— 30°— throughout all the letters. That way the ends of the strokes will meet sharply and overlap exactly.

Second, observe the suggested order and direction of strokes. This will help your letters take shape smoothly & accurately. Third, practice the alphabet in letter families. These groupings will teach your eye much about the visual principles of the alphabet: how each letter resembles the others, yet is distinct from them.

BASIC BLOCK

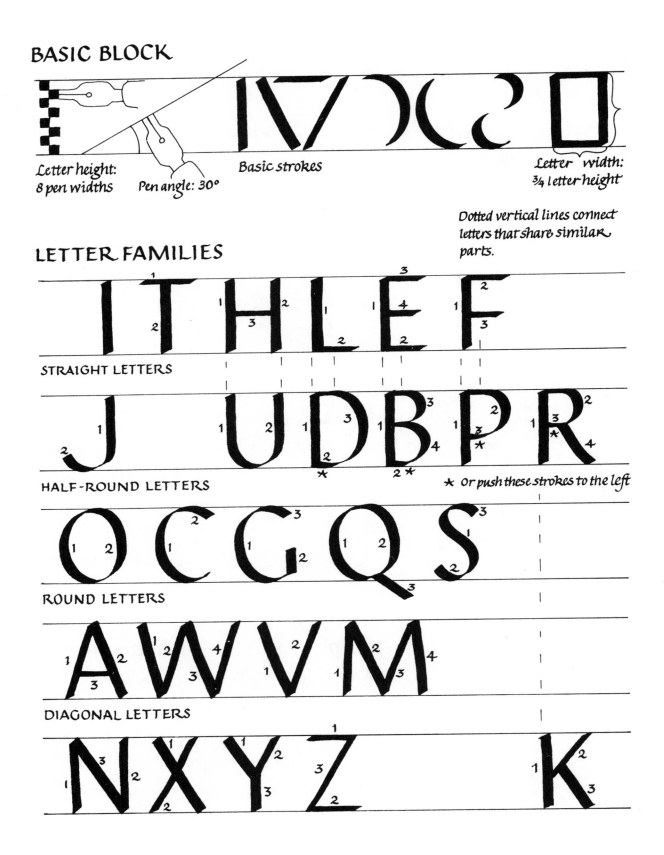

Letter height:
8 pen widths

Pen angle: 30°

Basic strokes

Letter width:
¾ letter height

Dotted vertical lines connect letters that share similar parts.

LETTER FAMILIES

STRAIGHT LETTERS

HALF-ROUND LETTERS

★ Or push these strokes to the left

ROUND LETTERS

DIAGONAL LETTERS

SPACING

To begin with, practice placing straight vertical strokes about 3 pen units apart.

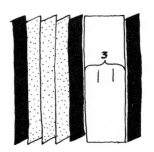

A curved stroke approaches a straight vertical one at a distance of about 2 pen units. Compare the white space with the rectangle above.

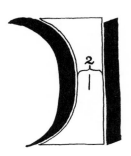

Two curved strokes are placed about one pen unit apart. Each space approximately equals the area of the others, giving a page of lettering an overall uniform texture.

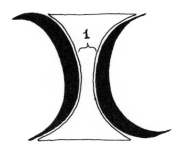

You should practice the basic strokes of Basic Block repeatedly before you put them together to form the letters. Don't just put your pen on automatic pilot, however, while you practice; use your eyes & brain to look for problems, solve them, and learn from your answers. If you practice in the pairs shown above, you can be well on your way to feeling in control not only of the letters but also, equally important, of the spaces between them. Use one, two, or three widths of the pen as a crutch to help you gauge the right amount of space at first.

The trapezoidal area between a diagonal stroke and a straight one must equal the triangle between 2 opposing diagonals or the parallelogram between 2 parallel ones.

A diagonal stroke next to a curve creates a more complex shape.

This letter pair traps the most space, and limits how close you can place all other letter pairs to each other.

Bear in mind that the space between L and V must equal the space between L and A (shown just above).
Experiment with these and other pairs of basic strokes to familiarize yourself with the visual vocabulary of white space between letters.

Try out some other stroke combinations, to familiarize yourself with spaces you will encounter. Do not continue using the width of the pen; estimate the area with your eye.

Block lettering is the real workhorse of alphabets. Use it for announcements, signs, and posters. Block lettering is easy to learn, to letter, and to read.

In addition, block letters have a transparent personality—they strike people as plain, bald, neutral, and self-effacing. You can turn this to your advantage when the message you are lettering has the same straightforward, unadorned quality.

NO
BARE FEET,
PETS, FOOD,
OR SKATE-
BOARDS !!!

WET
PAINT
FOR REAL !

AVERAGE PEOPLE

THE U.S. CENSUS DATA, AND
WHAT IT MEANS TO INDUSTRY.
NOV. 23, 7 P.M., HALEY HALL,
DR. ALAN BREAM, LECTURER.

Just because block lettering is the conservative business suit of calligraphy doesn't mean that you have to wear it everywhere with a white shirt. Vary it with a change of pen or mix two weights.

BONUS ALPHABET
Use a thinner pen to make a lightweight Basic Block letter.

ABCDEFGHIJK
LMNOPQRSTUVWXYZ

BLOCK MINUS knocks out a short section of the Basic Block letter's main strokes, creating paradoxically, the illusion of an added decorative element—a small white rectangle that catches the eye.

Start here. Stop here. Lift the pen, move it down, and restart here.

¼ pen width

Stop here.

Try to visualize the small rectangle of white that you are creating.

Each whole straight, curved, or diagonal stroke—as well as a few central joins—can be "broken." While there is some latitude in applying this rule, it is best if you start out learning to make every possible gap & then close them up according to the demands of your layout.

Use a clean, sharply trimmed pen on smooth paper for these letters, as a ragged line ending will rob the white gap of its eye-catching contours. Do not fiddle with any other part of the letter. The gap adds enough visual complexity to the alphabet; any more additions or subtractions will only dilute the effect (and incidentally also slow you down even more than all the stopping and starting already has).

AXR

Too complex

AXR

Correct

BLOCK MINUS

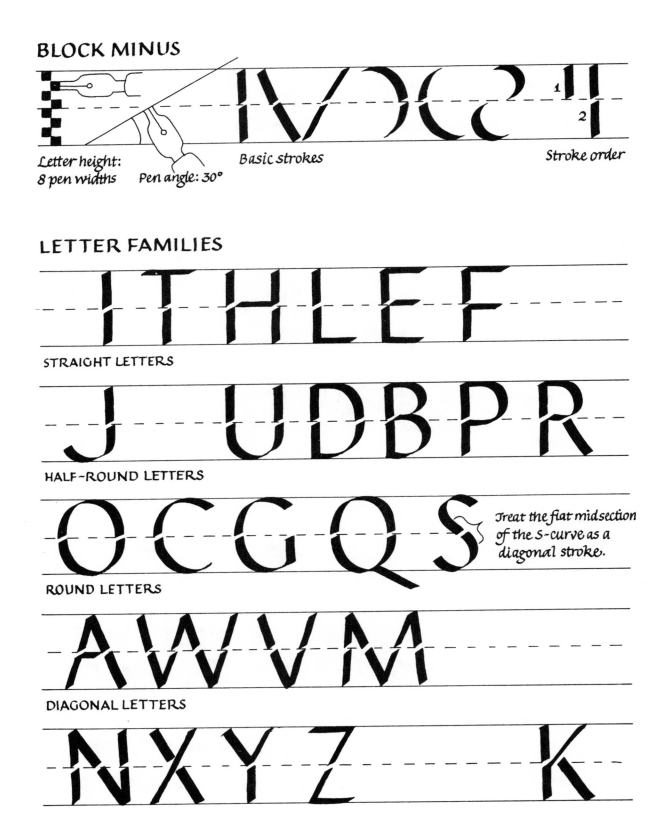

Letter height:
8 pen widths Pen angle: 30° Basic strokes Stroke order

LETTER FAMILIES

ITHLEF

STRAIGHT LETTERS

J UDBPR

HALF-ROUND LETTERS

OCGQS *Treat the flat midsection of the S-curve as a diagonal stroke.*

ROUND LETTERS

AWVM

DIAGONAL LETTERS

NXYZ K

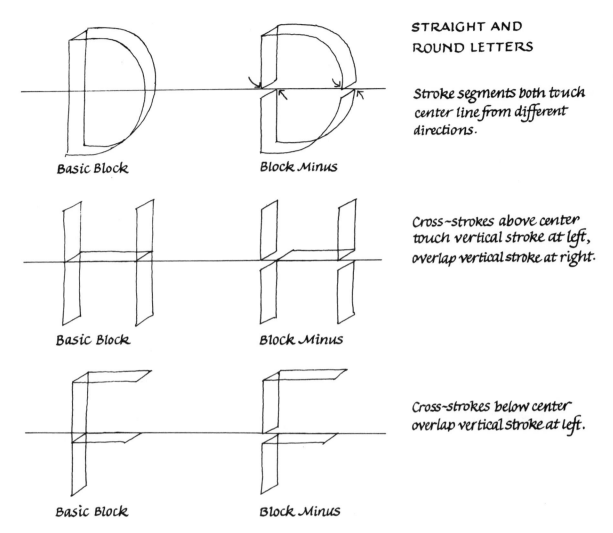

Stroke segments both touch center line from different directions.

Basic Block Block Minus

Cross-strokes above center touch vertical stroke at left, overlap vertical stroke at right.

Basic Block Block Minus

Cross-strokes below center overlap vertical stroke at left.

Basic Block Block Minus

Practice broken straight and curved strokes together, since the gap is virtually identical. You can "eyeball" the approximate amount of white space to leave by allowing the two segments to approach an imaginary (or pencilled) center guideline, touching it with their corners.

Cross-strokes cross either just above this line (H, E, B, and R) or just below it (F & P). Study the illustrations above to see how to handle joins for both these positions and at both left and right of the letter.

DIAGONAL LETTERS

Widen the gap in thin strokes.

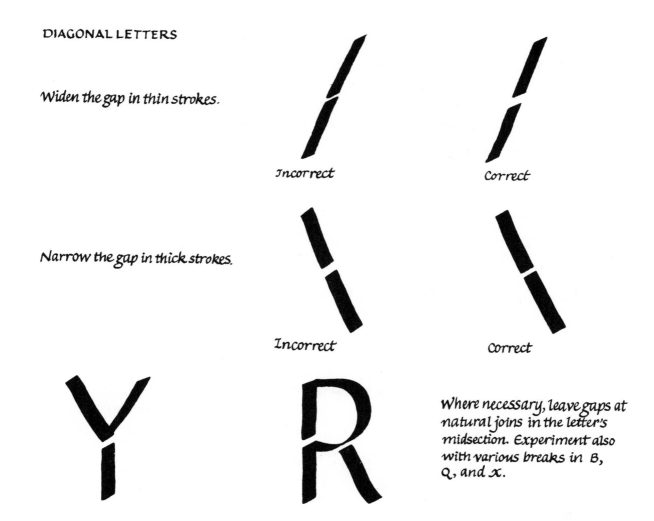

Incorrect Correct

Narrow the gap in thick strokes.

Incorrect Correct

Where necessary, leave gaps at natural joins in the letter's midsection. Experiment also with various breaks in B, Q, and X.

 Diagonal letters pose a slightly different spacing problem. If you simply line up the stroke ends along the center line, the right-leaning thin strokes will come too close together and the left-leaning thick strokes will lie too far apart. Compensate as shown above by letting thin strokes stop short of the center line, while thick strokes overlap it slightly.

 A few letters (X and Y primarily) offer no particularly good place for a break. Leave gaps at joins. On the other hand, R & K can break very naturally at the leg joins.

Block Minus letters are immediately beguiling to the viewer and yet subtly elegant. Use them—not too many nor too small—where you need to catch and hold the reader's eye.

If you have to be very sure that your readers can decipher your text without effort, close some of the gaps. You will still get most of the visual benefit of Block Minus. Compare the two versions shown here at right:

MENU

LIFT LATCH
THEN PUSH

LIFT LATCH
THEN PUSH

One curious characteristic of this alphabet is that, in the right context, it carries a hint of rusticity. The repeated gaps accentuate the line of writing. Put this to work for you with geometrically curved guidelines.

COUNTRY COMFORTS

BONUS ALPHABET
Leave 2 gaps to add extra complexity to lettering.

ABCDEFGHIJK
LMNOPQRSTUVWXYZ

BLOCK PLUS augments the major stroke of each Basic Block letter with an overlapping short pen stroke. Like Block Minus (pages 21~26), it leaves the pen angle & letter shape unchanged; the small extra stroke, however, has a big effect on the flavor of the alphabet.

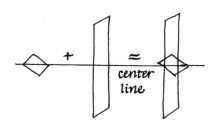

You can make the added stroke in a variety of shapes and place it high or low upon the alphabet's major stroke, or vary its placement from letter to letter. At the outset, however, limit yourself to one stroke and put it about halfway between bottom & top.

It also makes a big difference whether you place the short stroke on the center line, or to the left or right. Choose one spot— in this style, right on center— and stick to it; but try other positions when you experiment later with the many possible variations on Block Plus.

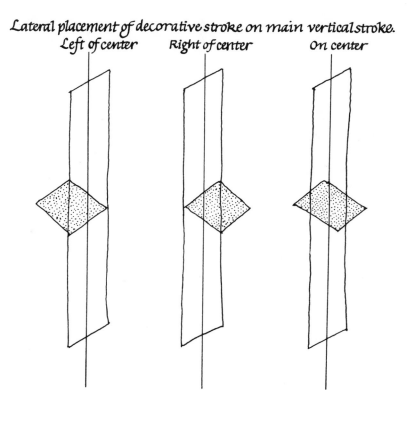

Lateral placement of decorative stroke on main vertical stroke.

Left of center Right of center On center

BLOCK PLUS

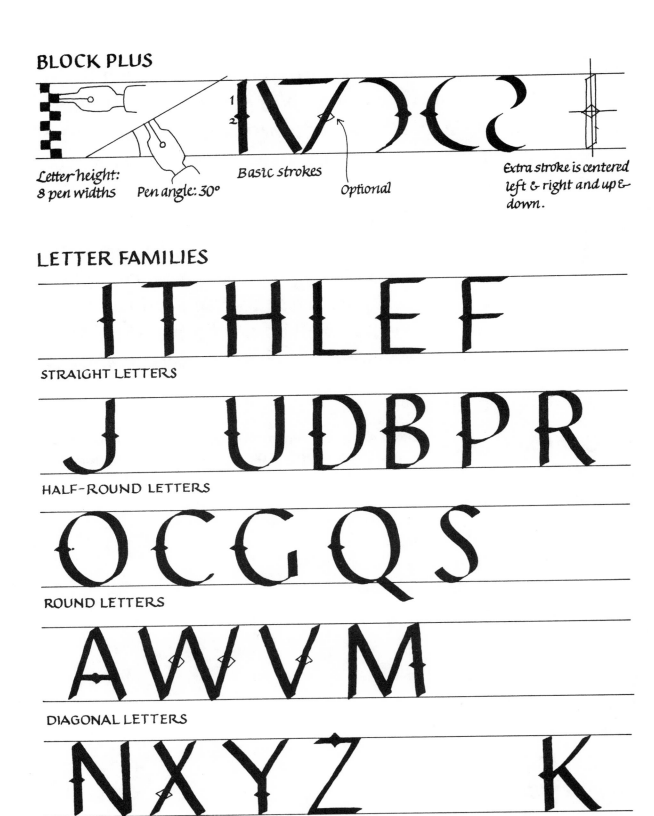

Letter height: 8 pen widths

Pen angle: 30°

Basic strokes

Optional

Extra stroke is centered left & right and up & down.

LETTER FAMILIES

ITHLEF

STRAIGHT LETTERS

J UDBPR

HALF-ROUND LETTERS

OCGQS

ROUND LETTERS

AWVM

DIAGONAL LETTERS

NXYZ K

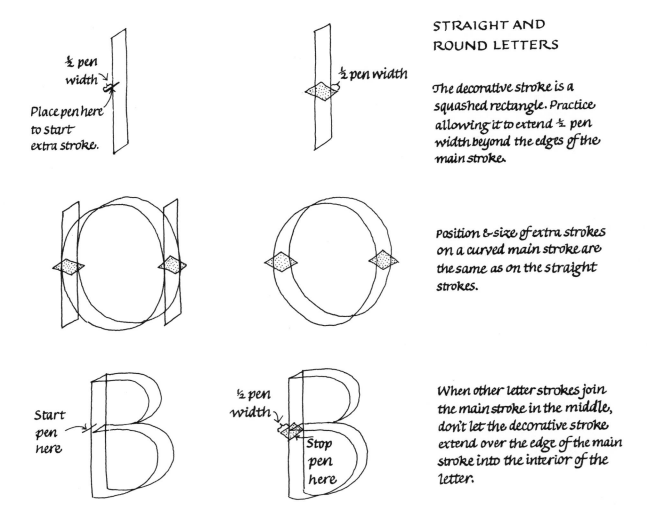

½ pen width↓

Place pen here to start extra stroke.

½ pen width

STRAIGHT AND ROUND LETTERS

The decorative stroke is a squashed rectangle. Practice allowing it to extend ½ pen width beyond the edges of the main stroke.

Position & size of extra strokes on a curved main stroke are the same as on the straight strokes.

Start pen here

½ pen width↓

Stop pen here

When other letter strokes join the main stroke in the middle, don't let the decorative stroke extend over the edge of the main stroke into the interior of the letter.

Straight and curved Basic Block letters are easy to transform into Block Plus. Simply superimpose the extra stroke onto one vertical stroke—usually, if there is a choice, at the left edge of the letter. Complete the letter before adding the stroke. This will give the ink on the main stroke a chance to dry, so the nib is not so likely to snag on a damp paper surface.

Letters with middle strokes (H, E, F, B, P, R, and K), require a truncated decorative stroke to avoid a cluttered intersection.

Incorrect Correct

DIAGONALS

A decorative stroke would coincide with the diagonal stroke of N, M, and Y, and so disappear. Put it on the vertical instead.

 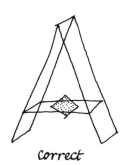

Incorrect Correct

While a diagonal stroke would possibly "fit" onto the thin diagonal of A & z, the vertical stroke is a better place. Try also adding the extra stroke to the cross stroke of H for variety.

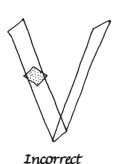 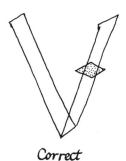

Incorrect Correct

The V and W offer only a thin diagonal for placing the extra stroke, and the S and X offer no useful sites at all. Simply omit, and let decoration on other letters establish the style.

Diagonal letters are not so straightforward; because the decorative stroke itself is also diagonal, it does not cross the main stroke but disappears into it. There are three solutions. First, some diagonal letters (N, M, and Y) also contain vertical strokes. Put the extra stroke there. Next, if there is no vertical stroke, add the extra stroke to a horizontal (A and z). Finally, four letters (S, V, W, and X) offer solely diagonals, with neither verticals nor horizontals; the best solution is just to omit the extra stroke and leave the letter plain.

The single small extra stroke of Block Plus and its numerous variations lets you dress up the Basic Block letter faster than almost any other pen technique. If you're in a hurry and need to give a little extra zip to a strong, simple layout, garnish a few letters as you go.

DON'T TOUCH

THE BEST OF 1987

Consider this alphabet's strengths & weaknesses. It adds pep to a plain letter without reducing legibility, but it does intensify the impersonal, public nature of Basic Block. Employ it for fanfare, not for intimacy.

ONCE UPON A TIME

You can easily vary the Block Plus letters shown in this chapter by detaching, raising, lowering, or omitting the decorative stroke. And try the effect of one or two "plussed" letters as initials.

MUSIC IS THE SOLE ART THAT EVOKES NOSTALGIA FOR THE FUTURE
• NED ROREM •

BONUS ALPHABET
Extra stroke embellishes Block Plus letter.

ABCDEFGHIJK
LMNOPQRSTUVWXYZ

SQUEEZED BLOCK introduces relativity to the Basic Block alphabet. Each letter is narrowed by about one-third, making it slender but not cramped. Since most Basic Block letters are about three-quarters as wide as their height, the Squeezed Block letters will be about one-half as wide as their height. The squeezed M and W will end up just slightly wider than the rest of the Squeezed Block alphabet.

EUDOAM
Basic Block

EUDOAM
Squeezed Block

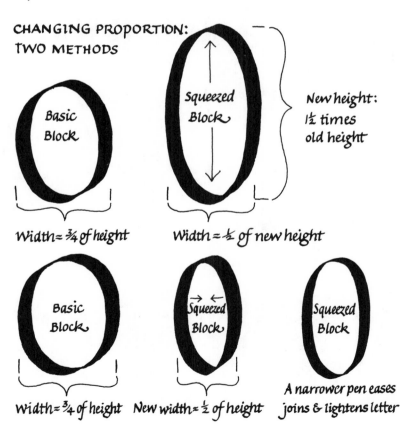

CHANGING PROPORTION:
TWO METHODS

Basic Block

Squeezed Block

New height: 1½ times old height

Width = ¾ of height

Width = ½ of new height

Basic Block

Squeezed Block

Squeezed Block

Width = ¾ of height

New width = ½ of height

A narrower pen eases joins & lightens letter

In transforming the Basic Block alphabet into Squeezed Block, you can take your choice: make the letter taller & keep the width the same, or narrow the letter and keep the height the same. If you pick the latter, however, you may find that your pen width is a little heavy, making the letter less legible & the joins awkward & bulky. Switch to a thinner pen, or else enlarge the size of the whole letter.

SQUEEZED BLOCK

Letter height: Pen angle: 30° Basic strokes Basic WIDE LETTERS
12 pen widths letter
 proportion

LETTER FAMILIES

ITHLEF

STRAIGHT LETTERS

J UDBPR

HALF-ROUND LETTERS

OCGQS

ROUND LETTERS

AVNXYZK

DIAGONAL LETTERS

DIAGONAL LETTERS

The midstroke of N becomes more steeply slanted as the verticals get closer together.

Both major strokes of A, V, and X slant more steeply as the letter narrows.

Y's arms get closer together.

Compare each Basic Block letter with its squeezed version. Pay attention to every stroke that isn't vertical, imagining its position on an imaginary grid behind the letter.

STRAIGHT AND
CURVED LETTERS

Squeeze the O equally along
all parts of the curves.

Keep corner joins square.

Squeezing straight Basic Block letters (T, H, L, E, & F) is simple; just move the verticals inward and shorten the horizontals. But notice how the curved strokes are altered when you squeeze them. Practice narrowing the two O-strokes, before you advance to the smaller half-curves; watch potential problem areas at the thinnest part, where the strokes must join without overlapping & at the outer edge of the curve, which must not droop, bulge, or collapse. If you have recurring problems with joining the curves, you may find that a narrower pen width or a steeper pen angle will ease joins together.

O OO
Correct Incorrect

The Squeezed Block alphabet lends very human qualities to any layout where you use it for emphasis. It is like tightening your voice or raising your eyebrows while you deliver the punch line of a story. It can be subtly humorous, too; watch out for this characteristic if your text must maintain a straight face.

Use Squeezed Block, of course, in any tight spot where there is more text than Basic Block would let you fit into the available space.

DON'T JUST
GET MAD —
GET WELL!

NOW SHOWING:
'BABES IN THE
WOODS' 7:45 P.M.

THIS
WAY

In visual terms, a slight squeeze helps compensate for the distortion of fore-shortening if your lettering is to be seen from a shallow angle below. Experiment with this phenomenon in other styles.

BONUS ALPHABET
Squeeze letters down instead of sideways.

ABCDEFGHIJKLM
NOPQRSTUVWXYZ

DECO BLOCK shows how a slight change in the proportions of the Basic Block alphabet can create an illusion of the decorative arts of a bygone age. A few additional changes in pen angle will heighten the nostalgic effect.

O O
Basic Block Deco Block
A A
H H
E E

First, look at letter proportion. Art Deco, popular in the 1920s and 1930s, was based on simple geometric forms: the circle and half-circle, the straight line, and the equilateral triangle. Find Basic Block letters that approximate these forms, and then push the letters toward more rigid geometry. Many Basic Block letters make subtle concessions to the eye in the placement of their middle strokes: Deco Block letterstrokes, however, cross at either dead center or extra low or high.

Deco Block demands several pen angles to achieve the dramatic contrast between its thick & thin strokes. You can shift the pen with your fingers & thumb, keeping your hand still, or you can hold the pen still and reposition your arm.

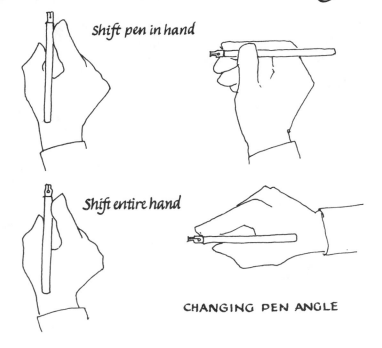

Shift pen in hand

Shift entire hand

CHANGING PEN ANGLE

DECO BLOCK

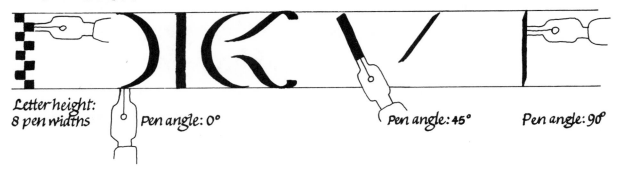

Letter height:
8 pen widths Pen angle: 0° Pen angle: 45° Pen angle: 90°

LETTER FAMILIES

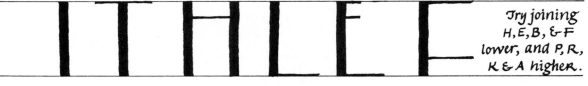

*Try joining
H, E, B, & F
lower, and P, R,
K & A higher.*

STRAIGHT LETTERS

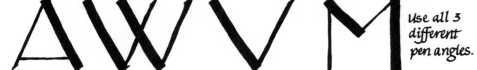

HALF-ROUND LETTERS

*3 exceptions
to geometric
letter construction: R, S, & K*

ROUND LETTERS

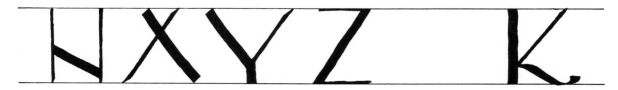

*Use all 3
different
pen angles.*

DIAGONAL LETTERS

STRAIGHT AND ROUND LETTERS

If horizontals are too thin for easy legibility, turn the pen angle slightly off flat, to add weight.

The O, C, G, Q, D, B, P, and R curves follow a geometric circle. Make a smooth transition between thick & thin, and be sure the joins are absolutely accurate.

S-curves should be straight except for the last 10% at each end; bend this very slightly.

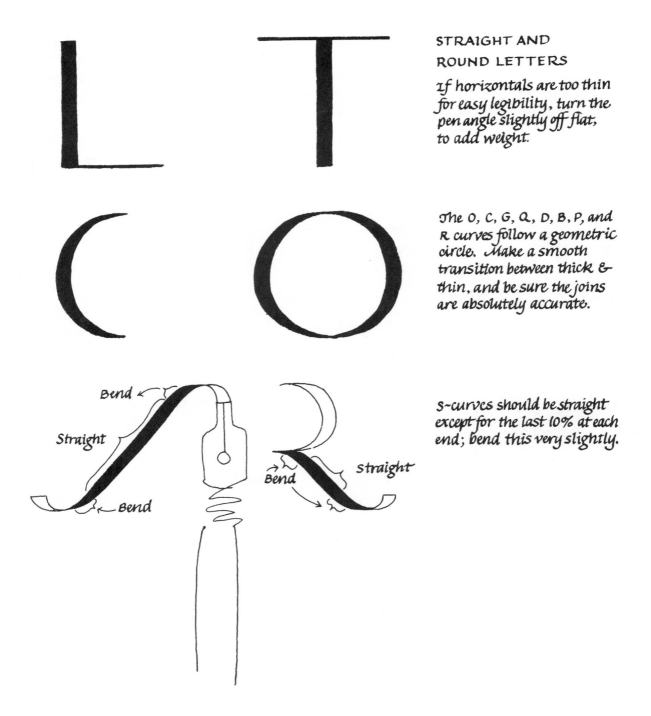

Letters written with a flat pen angle can be straight, circular, or S-curved. Verticals will be very thick, while horizontals will be very thin.

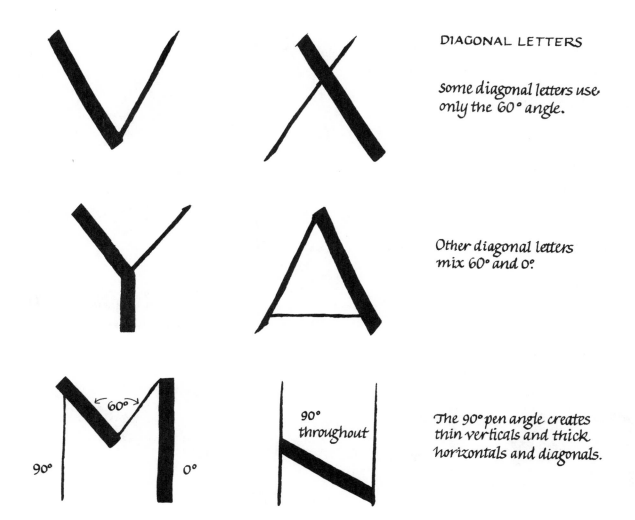

DIAGONAL LETTERS

some diagonal letters use only the 60° angle.

Other diagonal letters mix 60° and 0°.

The 90° pen angle creates thin verticals and thick horizontals and diagonals.

Nearly all the letters with diagonal strokes (except N, R, and Z), require you to shift the pen to a 60° angle to maintain a sharp contrast between thick and thin strokes. Get used to shifting the angle between letters readily, because you will need to shift it similarly between strokes in the letters A, M, and Y, each of which contains both flat-angle & 60° angle strokes. In addition, the first stroke of M requires yet another angle, of 90° (a right angle), which is used, without shifting, throughout the letter N.

Use Deco Block letters for posters, dance programs, party graphics, —anywhere, in fact, where stylishness is more important than legibility. If you need readability (i.e., for name tags or large amounts of text), you can "tone down" the exaggerated geometric abstraction of most of the letters, retaining only a few distinctive Deco Block letters to set the style.

BLACK
TIE &
WHITE
GARDENIA

Decorate your Deco page, and hone your calligraphic skills in practice, with a geometric pattern of repetitive thick & thin pen strokes. Show any real objects & human figures in silhouette.

SCHOLARSHIP FUND BENEFIT
Lesley College Alumni Association
CONTINENTAL BREAKFAST
& FASHION SHOW
LORD & TAYLOR BIRDCAGE RESTAURANT
750 BOYLSTON STREET, BOSTON
SATURDAY, JANUARY 24, '76, AT 9:30 A.M.

FASHIONS BY Lord & Taylor

☐ YES I'm coming to the Lord & Taylor Breakfast
Fashion Show. I will bring _____ guests.
☐ NO I'm unable to attend but wish to contribute
to the Scholarship Fund.

DONATION

$4.00 per person.
Enclosed $_____

Name_____ Class_____
Address_____
City_____ State____ Zip
PLEASE RETURN by January 15 to:
Alumni Office, Lesley College, 29 Everett
Street, Cambridge, Massachusetts 02138

BONUS ALPHABET

Mix these Deco alternates with Basic Block or Deco Block.

ABCDEFGHIJK
LMNOPQRSTUVWXYZ

DOUBLE BLOCK energizes the Basic Block alphabet by replacing the major broad strokes in each letter with a pair of narrow strokes. A thin strip of white space separates the two strokes from beginning to end, so that they never touch.

Choose a pen that is a little over half the width of the original solid stroke, & space these two narrow strokes about one-half pen width apart. The final doubled pen stroke will be a little wider than the solid original.

Basic Block Double Block

Double block is a demanding exercise in maintaining a steady hand and keeping your eye on your pen. Repeat the practice strokes over and over, striving not just for an even strip of white space but for strips of the same width from stroke to stroke. As with letter spacing (pages 18–19), you will establish more control if you watch the white space, rather than the black stroke, take shape.

½ pen width

1 1 2

POTENTIAL PROBLEMS

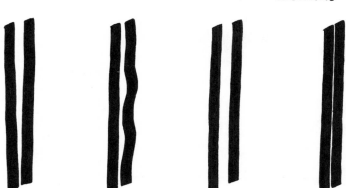

Guard against the following problems (illustrated at left): leaning strokes, wiggling strokes, excess white space, insufficient white space.

DOUBLE BLOCK

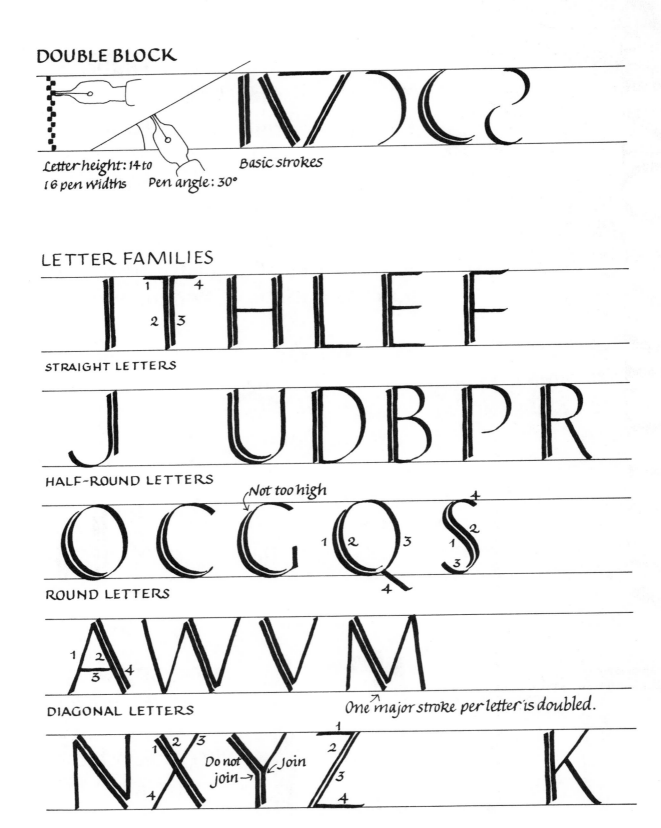

Letter height: 14 to
16 pen widths Pen angle: 30° Basic strokes

LETTER FAMILIES

ITHLEF

STRAIGHT LETTERS

JUDBPR

HALF-ROUND LETTERS

Not too high

OCGQS

ROUND LETTERS

AWVM

DIAGONAL LETTERS One major stroke per letter is doubled.

NXYZ K

Do not
join → ← Join

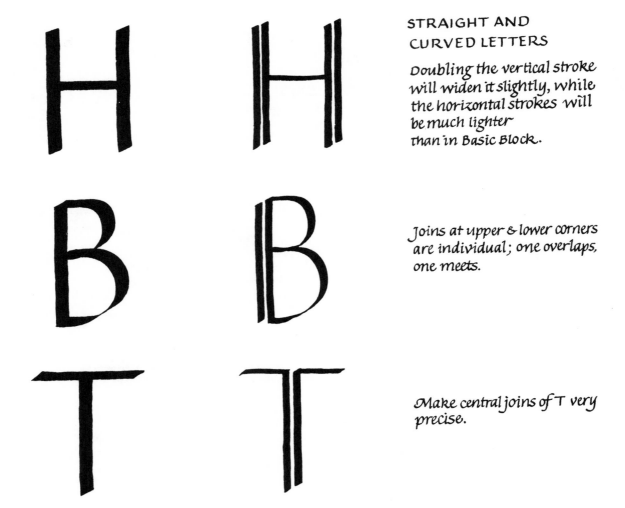

STRAIGHT AND
CURVED LETTERS

Doubling the vertical stroke
will widen it slightly, while
the horizontal strokes will
be much lighter
than in Basic Block.

Joins at upper & lower corners
are individual; one overlaps,
one meets.

Make central joins of T very
precise.

Double Block letters will carry more visual
impact if you carefully tailor the joins and stroke endings. On
free straight ends, maintain the slanted outline of the original
solid stroke. On square lower corners, bring the left edges of both
strokes down to the base line, to seat the letter firmly.

Note that, as with Basic Block, the corner
joins of half-round letters are not identical: strokes overlap at
upper corner & touch at lower corner. Both joins appear at stroke
intersection of T.

DIAGONAL LETTERS

Watch corners carefully

N N

Keep this up high

Keep white space of uniform width from top to bottom of curve; do not let it widen & narrow as the black curves do.

Q Q

Double the right stroke of J, but the left side of U, because historically U evolved from a V with a heavy left stroke.

J J

When adapting diagonal letters to Double Block, sacrifice truly neat corners for the sake of stroke separation and letter proportion. Keep your eye — and the viewer's — on where the corner really is.

Most letters do not need more than one curve doubled. (But use your judgement, since many alternate versions are possible.) Letter strokes can coil up without overlapping, or cross each other, or match curved to straight if you have kept the basic idea simple.

Double Block blends complexity with simplicity, elegance with pizazz. Use it for headlines, brief passages, initials, titles, and logos. The fewer letters the better.

The larger the better, too. The beauty of the joins is lost in small sizes, and the rhythm of the repeated white strip becomes visually insignificant and physically difficult to sustain.

YES

GOLDEN DREAMS

Double Block is an absolute life saver when you have to produce something under time pressure and you discover that your pen is too narrow to make any impact with a one-stroke Basic Block. Double or triple the stroke to widen it.

GALA

Basic Block

GALA

Double Block

GALA

A doubled version of Deco Block (pages 39–44).

BONUS ALPHABET

Give Double Block a rustic look by curving strokes to meet at center.

A B C D E F G H I J K
L M N O P Q R S T U V W X Y Z

CHIP OFF, the next of many variations on those Basic Block letters you learned at the start, adds by subtracting: shortening some of the strokes creates a small wedge of white space at the corners and joins of the letters, where horizontal and vertical strokes meet each other. This "lightens up" the joins by having the strokes touch rather than overlap. This seemingly simple change adds visual liveliness while it teaches the calligrapher to use the ends, as well as the edges, of the stroke to shape the white space in and around the letter.

In addition, once you have mastered the fundamental principle of this style, you can try "chipping off" the joins of other basic alphabet styles.

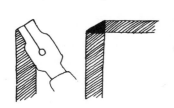

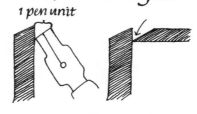
1 pen unit

Instead of starting the horizontal stroke with the pen in exactly the same place where it began, overlapping the vertical stroke...

...the pen is positioned one pen width away so that its _left_ edge just touches the _right_ edge of the vertical stroke. (arrow)

To help your eye guide your pen, you should get used to thinking in units the width or height of the broad-edged pen. (see illustrations on this page.) Strive for precision. You can "chip off" or leave unaltered any of the joins of Basic Block letters as long as you make it clear which is which.

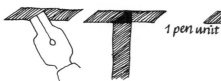

1 pen unit

Similarly, the vertical stroke, instead of starting from within the horizontal stroke...

...can begin with the _right_ edge of the pen just touching the _lower_ edge of the stroke. (arrow)

E EEE EE

Basic Block. "Chipped-off" variations.

Incorrect, imprecisely joined attempts at variations.

CHIP OFF

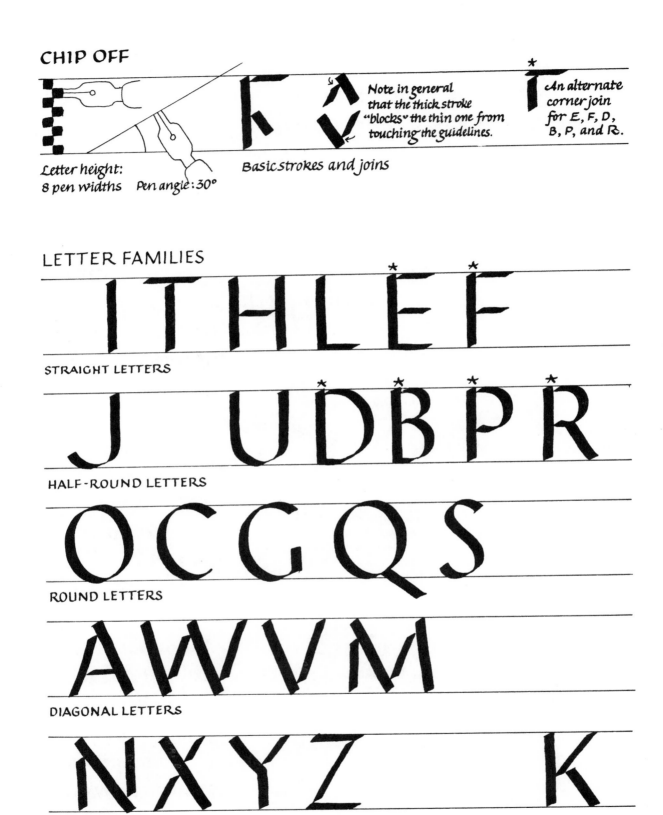

Note in general that the thick stroke "blocks" the thin one from touching the guidelines.

An alternate corner join for E, F, D, B, P, and R.

Letter height: 8 pen widths　　Pen angle: 30°

Basic strokes and joins

LETTER FAMILIES

I T H L E F

STRAIGHT LETTERS

J　U D B P R

HALF-ROUND LETTERS

O C G Q S

ROUND LETTERS

A W V M

DIAGONAL LETTERS

N X Y Z　　K

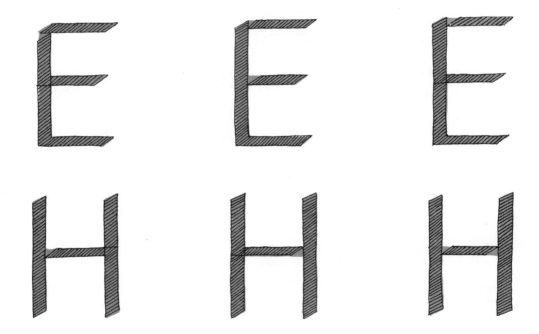

Straight Chip Off letters offer a variety of corner chips. Try them all out as you work your way through this alphabet, as they will sharpen your eye while they expand your repertoire.

Note that not only the upper left corner joins but also the mid-letter joins leave a small triangle of white rather than solidly overlapping the vertical stroke. Do not try to chip off the lower left corner; this join, where horizontal and vertical just meet, should be left intact.

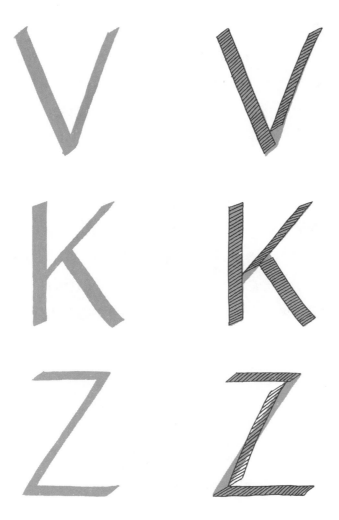

Diagonal Chip Off letters do not offer so much choice at the joins. The thick stroke will generally take precedence over the thin one. The resulting triangle will be larger than you might expect, judging from the straight letters; don't try to reduce it by overlapping or you'll spoil the letter.

Almost all the letters in this alphabet follow the Basic Block strokes, simply stopping short at the joins. Z and K, however, are exceptions. To provide a triangular gap in keeping with the other letters, one stroke in each is realigned slightly.

SEE ME NOW

SEE ME NOW

Chip Off is a more sophisticated version of Basic Block, and as such can elevate even a very pedestrian piece of text into something with a subtle snap & visual intrigue. Since it takes no longer than Basic Block to letter, you should substitute it for the Basic Block style on occasion and gauge the results with your own eye. Squint at the lettering, step back & view it from a distance, turn it upside-down, glance at it out of the corner of your eye — anything to get a fresh, unbiased view of it.

Use Chip Off in ways that show the letters in the best light. Do not write them too small, nor with a narrower pen than ⅛ the letter height as suggested in the Master Sheet (page 52). In fact, a slightly heavier pen highlights the chipped-off joins.

RESOLVE

AND THOU ART FREE.
RALPH WALDO EMERSON

BONUS ALPHABET

A heavy version of Chip Off.

ABCDEFGHIJK
LMNOPQRSTUVWXYZ

CHIP-OFF SERIF *exploits the technique for joining the letter strokes by letting them just touch. In this style, the serifs, also, just touch the letter strokes, creating additional repeated wedges of white throughout the alphabet.*

Keep "chip-off" serifs from looking choppy by choosing the pen width carefully. Too wide, and you will overemphasize the white "chips" at the expense of letter integrity. Too narrow, and the "chips" will lose their impact.

Incorrect weight Correct weight

Accurate joins are essential to these letters. They may need extra attention where the vertical stroke of the letter joins the lower serif; you must learn to stop this stroke short of the guideline by exactly the right amount to allow for the width of the pen stroke. Try to visualize an imaginary line, or pencil one in to train your eye at first.

LETTER CONSTRUCTION

Start horizontal stroke 1 pen unit beyond vertical.

1 pen unit

Start vertical stroke 1 pen unit from upper guideline.

Stop horizontal mid stroke 1 pen unit from vertical stroke.

Stop vertical stroke 1 pen unit from lower guideline.

stop diagonal stroke 1 pen unit from lower guideline.

1 pen unit

Serifs are 3 pen units wide.

CHIP-OFF SERIF

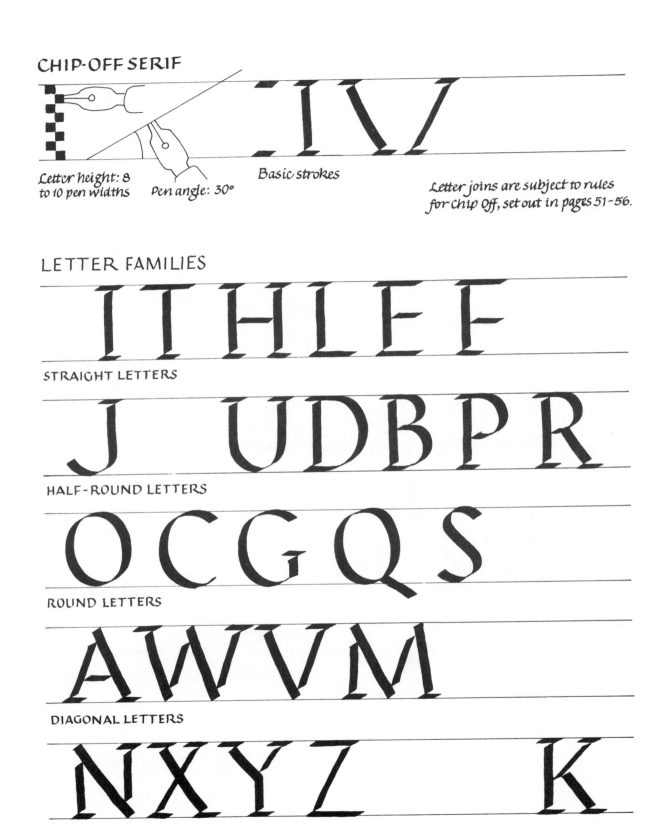

Letter height: 8 to 10 pen widths Pen angle: 30° Basic strokes

Letter joins are subject to rules for chip off, set out in pages 51-56.

LETTER FAMILIES

ITHLEF

STRAIGHT LETTERS

J UDBPR

HALF-ROUND LETTERS

OCGQS

ROUND LETTERS

AWVM

DIAGONAL LETTERS

NXYZ K

STRAIGHT LETTERS

Add a serif to the top of L, J, and U; the bottom of F, P, and T; the left stroke of R and K; the free corners of N; the up-right chin of G; and both top and bottom of I and H.

Extend the horizontal strokes to form serifs on the top of R, P, and F; the bottom of L; and both top and bottom of D, B, and E.

As with the chip-off alphabet, the middle stroke just barely touches the vertical stroke of A, H, E, R, B, P, and F.

The Chip-Off Serif alphabet follows a very clear set of rules, which are applied uniformly to an overlapping set of letter families. Thus, for instance, the upper & lower strokes of E follow one rule, the middle stroke follows another. This keeps all the dissimilar letters & serifs integrated into a harmonious whole.

The letters shown above embody the three basic rules governing straight letters and the straight parts of diagonal and curved letters.

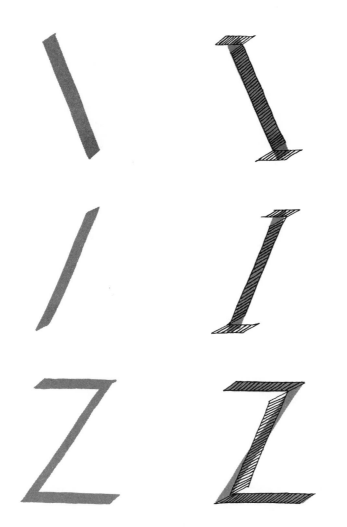

Visualize two lines to help you place serifs precisely & make them the right length.

First, the bottom end of the main stroke and left end of serif forms a perfectly straight line 2 pen widths long. (All letters with serifs are built on this architecture, but it is of particular utility in the diagonal letters.)

Second, to determine where to stop the serif, drop an imaginary line straight down from the lower right corner of the main stroke. Do not visualize a continuation of the main stroke itself: the resulting stroke will be too long.

Note similarity of thin-stroke serifs and the z corner joins.

Diagonal strokes create a more complicated geometry; more care is needed to place the serifs so that they touch the strokes precisely at the corners without gaps or overlaps. To a certain extent, you must contradict your own eye, which will seek to balance the thinner and thicker diagonal strokes against the mid-weight straight ones by squeezing or stretching the serif to compensate. Resist this otherwise reasonable impulse, and keep serifs all the same length throughout the alphabet to unify the style.

Since the Chip - Off Serif alphabet is not only slow to letter but visually complex, use it sparingly. It must be large to be precise, and it must be precise to be worth doing.

EXHIBITION TODAY ⟶

CORNERSTONES OF HISTORY IN WEST- PORT

A WALKING TOUR· SATURDAY, MAY 12, 10:00 A.M.

your layout should take into account the way the flat slab of the serif carries the eye along the hori- zontal line. Do not dislocate the letters from this line, or the words will give a jumbled, choppy im- pression.

BONUS ALPHABET
curve main stroke and serif for a softer Chip-Off Serif.

ABCDEFGHIJK
LMNOPQRSTUVWXYZ

BLOCK SERIF introduces the beginning calligrapher to one of the most powerful tools for alphabet variation–the serif. In this chapter it is a short stroke at the beginning and end of all vertical strokes and most diagonal ones. Serifs on diagonal~ vertical joins are optional, and serifs on horizontal strokes will be dealt with in the chapter on skating (pages 87-92).

If you have been ig- noring the rule about pen width ratio until now, perhaps producing a relatively heavy letter, this is the time to put your alphabet on a reducing diet. Serifs will transform a slightly overweight letter into a sluggish, un- readable one.

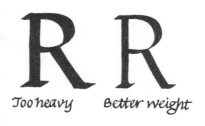

Too heavy Better weight

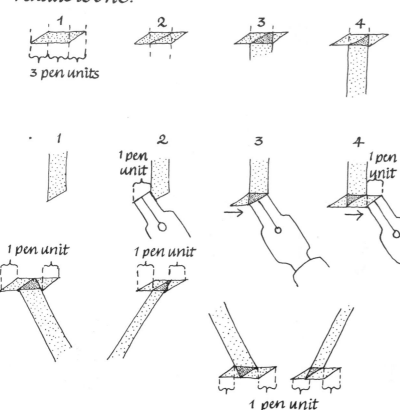

1

3 pen units

2

3

4

1

2

1 pen unit

3

4

1 pen unit

1 pen unit

1 pen unit

1 pen unit

1 pen unit

Serifs must be precise. Start them one unit —that is, one width of the pen—to the left of where the left edge of the vertical stroke will be, and end it one unit to the right of the right edge. These rules will help you keep the serif the right length to anchor the stroke: not short and stubby nor long and spindly.

BLOCK SERIF

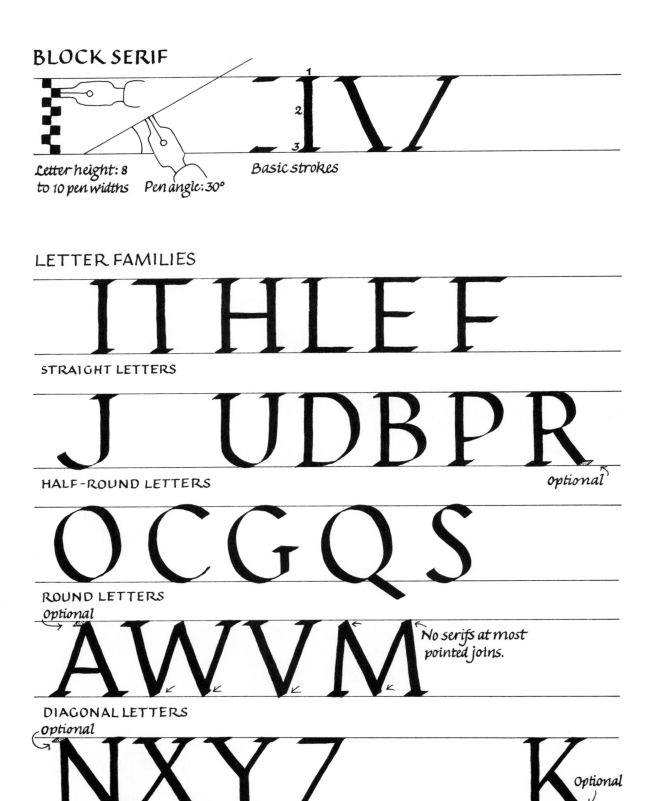

Letter height: 8 to 10 pen widths Pen angle: 30° Basic strokes

LETTER FAMILIES

I T H L E F

STRAIGHT LETTERS

J U D B P R

Optional

HALF-ROUND LETTERS

O C G Q S

ROUND LETTERS

Optional A W V M No serifs at most pointed joins.

DIAGONAL LETTERS

Optional N X Y Z K *Optional*

T T

Add serif at bottom of vertical stroke. (No serifs on the free ends of horizontal strokes in this alphabet.)

L L

P P

Horizontal strokes extend past vertical stroke to form serifs at letter corner but not in middle of letter.

Serifs can either stand alone on the free ends of vertical strokes, or form an extension of a horizontal stroke at the corner where it joins a vertical stroke.

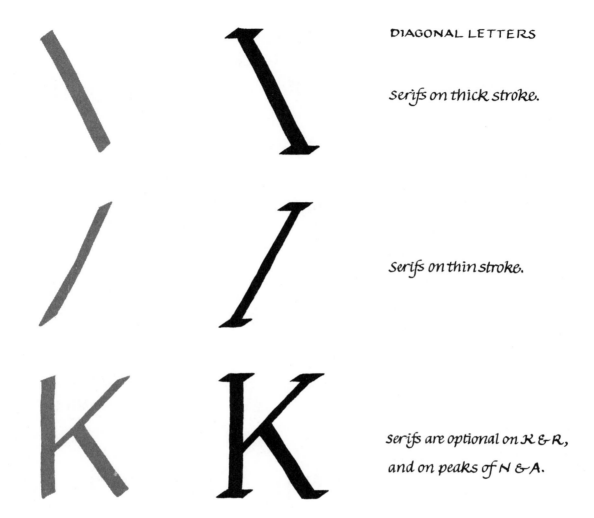

DIAGONAL LETTERS

Serifs on thick stroke.

Serifs on thin stroke.

Serifs are optional on K & R, and on peaks of N & A.

Only three serif configurations are possible on diagonal letters. The first attaches to a left-leaning thick stroke. The second attaches to a right-leaning thin stroke. The third is a half-stroke that extends only to the right of the "leg" stroke of R and K. This half-serif, like the one that can extend left from the top of A and N, is optional; add it when the letter seems bare without it compared to the other letters in the text; omit it when its inclusion would make the overall layout seem repetitious, heavy, and cluttered.

In many calligraphy projects where Basic Block is just adequate, Block Serif will be terrific. The finished line endings add an air of formality, the serif shapes create extra visual liveliness, & the simple fact that there is more ink on the page gives the message more weight.

NOTICE

NOTICE

1987
GRADUATES
Edwards School
Sixth Grade

Polly Peterson
Maria Steiner
Frederick Day
Melanie Moyers
Richard Blacke
Cathy Legvold
Ken Duncan
Joyce Johnson

Mike Hildebrand
Ellen Feinberg
Raymond Williamson
Heather Delaney

Morris Field
Mary Banke
Gary Folley
Francine Amari
Deborah Richards
Latoya Morriss
Chris Melnakoff
Laura Chan

Be sure not to crowd your lines of lettering too close together; not only will your serifs lose impact but also the legibility will suffer.

Exploit Block Serif's resemblance to the Roman capitals when the text is classical, official, or monumental. Use a slightly thinner pen for a more elegant letter.

JUDGE NOT, THAT YE BE NOT JUDGED.
MATTHEW 7:1

BONUS ALPHABET
A lightweight Block Serif.

A B C D E F G H I J K
L M N O P Q R S T U V W X Y Z

OFF HAND is a style created by speed, which transforms the strait-laced, formal block letter into an unbuttoned, informal alphabet. Because the serifs, swashes, and joins emerge naturally from each individual writer's pattern of hand motions, the reward for exploring this alphabet is a personal, flexible, "signature" style unmistakeably your own.

The method for creating your version of this style could not be much simpler: write block letters quickly, in sentences, with a fountain pen or small marker. Select the most definite, appealing examples from these letters, and copy them exactly with a large pen. This is your own alphabet.

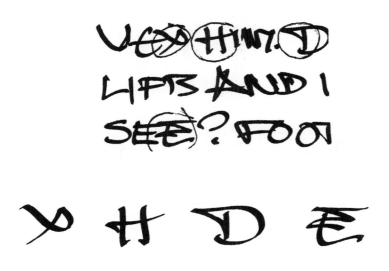

Deriving Off Hand letters.

At first the results may strike you as messy or chaotic. The haste of a well-trained hand, however, if analyzed with an informed eye, can actually invent new letter styles. Study the selection of Off Hand letters to find and accentuate the characteristics of a bona fide alphabet style; variety yet similarity in the letter shapes, joins, and connections.

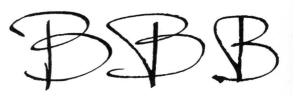

OFF HAND

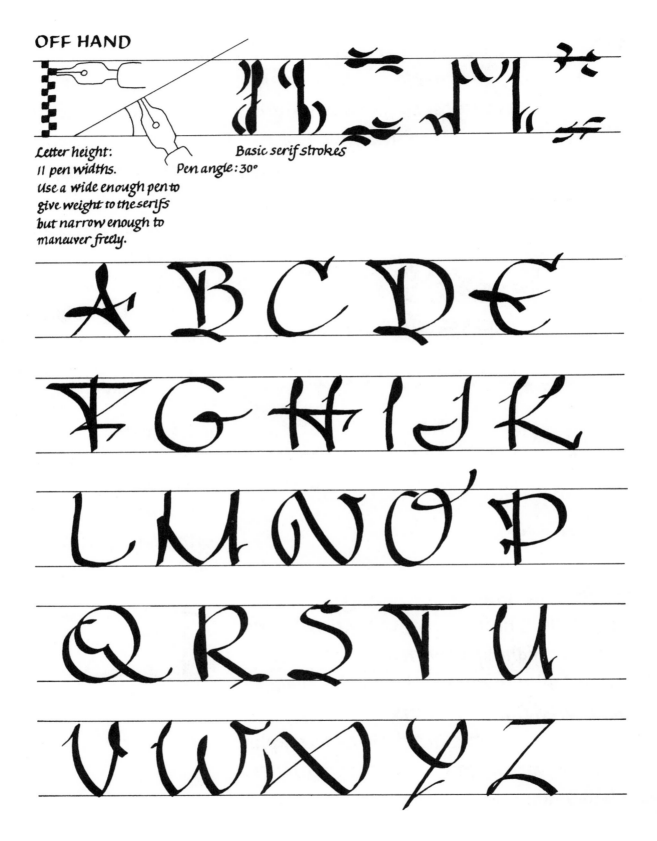

Letter height:
11 pen widths.
Use a wide enough pen to
give weight to the serifs
but narrow enough to
maneuver freely.

Basic serif strokes

Pen angle: 30°

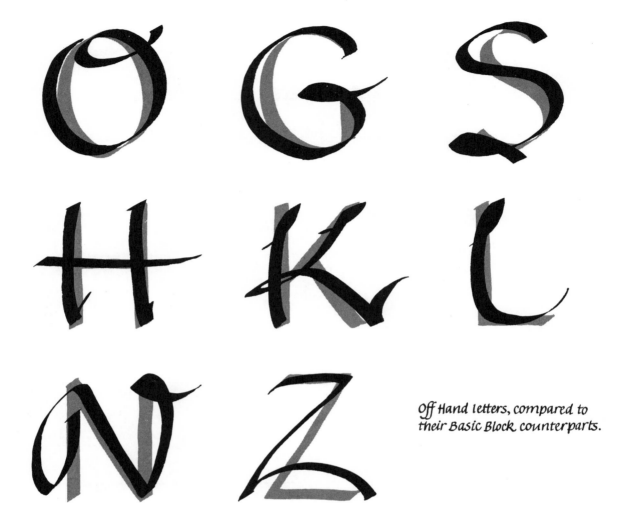

Off Hand letters, compared to
their Basic Block counterparts.

Two major changes happen to Basic Block when
you write it fast rather than letter it slowly. First, each letter shape
loses its geometric regularity and that shape can vary every time
the letter appears. Round letters will arch off course. Straight letters
will bend slightly. Diagonal letters will lean and curve. And letters
with center strokes will become exaggeratedly high-waisted or
low-waisted. Overall, the alphabet acquires a sense of vitality and
motion—or rather, seems to reveal forces that the disciplined limits
of Basic Block held in check.

The pen's path is made visible when the nib is kept in contact with the paper in between strokes and letters.

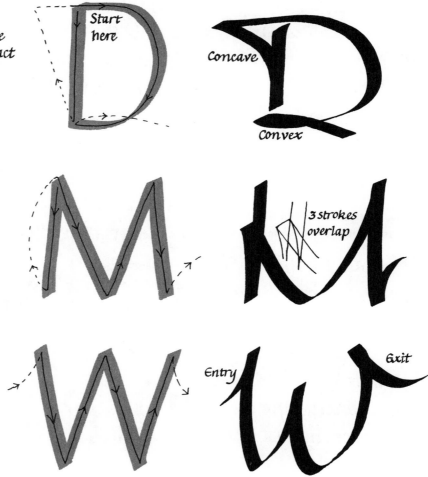

The second big change transforms the simplest joins and stroke endings into a lively array of swashed serifs. These result largely from not removing the pen from the paper at the end of the stroke before changing direction, so that the serif doubles back over the stroke. This curved serif can be convex or concave, gradual or abrupt. It can adhere to the stroke, making the visually intriguing clubbed serif. Or it can shear off in a new direction, to connect with or point to the beginning of the next stroke or the back of the next letter.

THE QUICK BROWN FOX JUMPS OVER THE LAZY DOG. ANGRY GODS JUST FLOCK UP TO QUIZ AND VEX HIM.

THE QUICK BROWN FOX JUMPS OVER THE LAZY DOG. ANGRY GODS JUST FLOCKED UP TO QUIZ AND VEX HIM.

Two samples of spontaneous connections. Courtesy Janet Fiske.

The alphabet shown in this chapter represents only the tiniest fraction of possible Off Hand letters. Not only will each calligrapher's idiosyncracies produce a distinctive personal style but the same person will not write this alphabet the same way from year to year, or even from day to day. Your Off Hand alphabet will continue to grow and change through~ out your writing lifetime.

In addition, Off Hand letters can be dressed up or down to suit a variety of occasions. Its manners can range from breezy informality to the slightest hint of warmth.

POET DIPLOMAT

After creating, analyzing, practicing, & using Off Hand letters, you can move on to apply the informalizing process to other alphabets you may know or encounter. Search for the essential structure of each style that will survive the pressures of speed, & keep an open mind, receptive to the many happy accidents of the pen.

BONUS ALPHABET

THE QUICK BROWN FOX JUMPS OVER THE LAZY DOG

BLOCK ITALIC adds emphasis to a text and a new element to the overall layout by slanting the Basic Block alphabet to the right. Nothing else about the letter changes, and yet this new style is immensely useful — almost more so than Basic Block. Block Italic has more energy and a sense of motion.

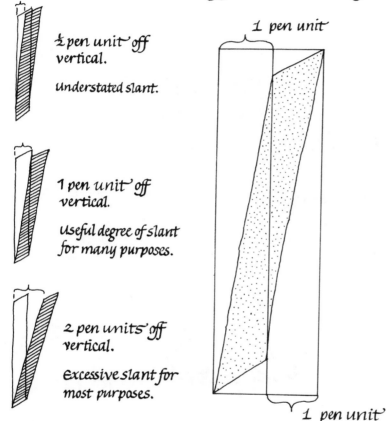

½ pen unit off vertical.

Understated slant.

1 pen unit off vertical.

Useful degree of slant for many purposes.

2 pen units off vertical.

Excessive slant for most purposes.

1 pen unit

1 pen unit

Maintaining this alphabet's slant is its primary challenge. First, determine how much slant you want the letter to have. Do not overdo it. Even a 10° slant off vertical can seem exaggerated. Use the width of your pen to estimate a slant of 1 to 8: the top of the letter will be one pen unit to the right of the bottom.

To keep the slant uniform from one letter to the next, observe how much it deviates from true vertical. Avoid changing the position of the paper or your body while you write, so that your viewing angle remains constant. And you can rule off pencil guidelines at an appropriate slant if you still need extra help.

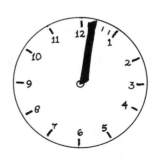

If you have trouble visualizing the slant, picture it on a clock face.

BLOCK ITALIC

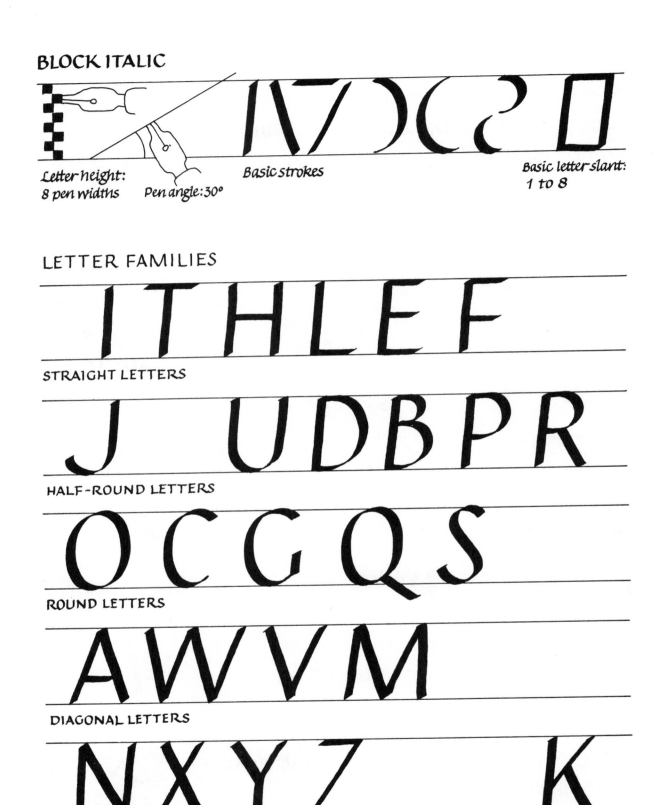

Letter height:
8 pen widths Pen angle: 30° Basic strokes Basic letter slant:
 1 to 8

LETTER FAMILIES

ITHLEF

STRAIGHT LETTERS

J UDBPR

HALF-ROUND LETTERS

OCGQS

ROUND LETTERS

AWVM

DIAGONAL LETTERS

NXYZ K

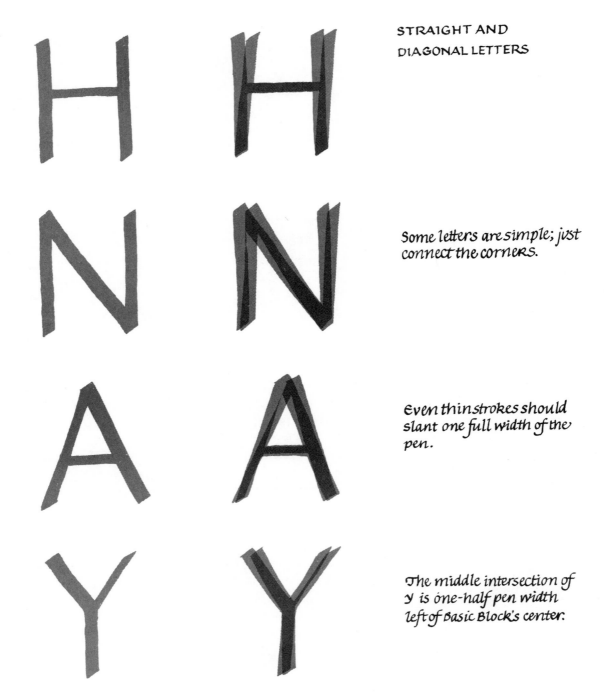

Some letters are simple; just
connect the corners.

Even thin strokes should
slant one full width of the
pen.

The middle intersection of
y is one-half pen width
left of Basic Block's center.

straight and diagonal Block Italic letters
start in the same place as Basic Block at the top and then end up one
pen width to the left at the bottom of the letter.

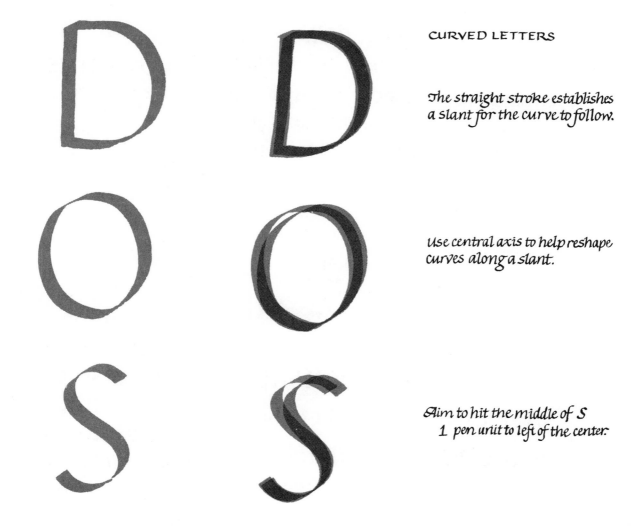

CURVED LETTERS

The straight stroke establishes a slant for the curve to follow.

Use central axis to help reshape curves along a slant.

Aim to hit the middle of S
1 pen unit to left of the center.

 Curved Block Italic letters need more visual estimating and less mental calculation than the straight and diagonal ones. The one-pen-unit rule will work when the letter is half round (D, B, P, R, U, and J), but for O, C, G, Q, and S you will need additional strategies to help your eye guide your hand. Imagine (or pencil in) a line that divides the letter in half vertically, slant this line one pen unit, and reshape the curved strokes along the new "vertical." For extra assistance with the freehand curves of S, seek a guidepoint mid-letter to aim at and orient your stroke.

Block Italic can be used almost anywhere that Basic Block can; for placards, directional signs, labels, posters, headlines, logos, invitations, place-cards, name tags, mailers, and banners.

MASTER OF CEREMONIES

PICKLES

MOVIE TIME
7:30
TICKETS GO
ON SALE AT
7:05

YOU MAY THINK YOU'RE SAFE WHEN YOU LOCK YOUR DOOR AT NIGHT;

BUT IT'S NOT TRUE.

Block Italic is especially useful for its emphasis. Put a few words of Basic Block into Block Italic, and the reader's eye will read them first and retain them longest. Don't mix Block Italic letters of two different slants, however; they will make you seasick.

BONUS ALPHABET
Slant Basic Block backwards for a startling effect.

ABCDEFGHIJK
LMNOPQRSTUVWXYZ

SWASH BLOCK builds on Block Italic (pages 75~80) and Chip~Off Serif (pages 57~62) to create a rich, spectacular, expressive alphabet that is fun to letter. You may find, in fact, that these extended, freeform strokes feel more natural to write than their stripped~down, controlled counterparts in the more sober styles. This very organic, fluid alphabet is founded on some simple rules; if you follow them strictly at the outset, you can bend them freely later on.

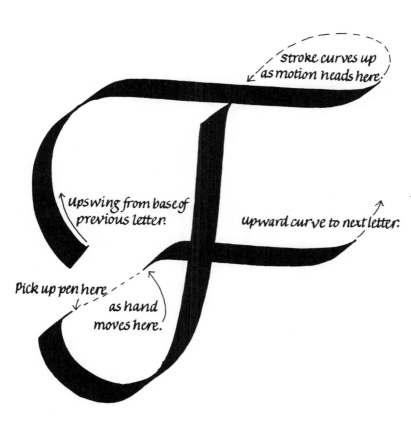

stroke curves up
as motion heads here.

upswing from base of
previous letter.

upward curve to next letter.

Pick up pen here
as hand
moves here.

Every stroke of the pen has momentum that would extend the stroke if you did not either stop the pen or lift it. A swash is just this momentum made visible either by touching the pen to the paper before the stroke begins, or else by leaving it in contact with the paper as momentum carries it beyond the end of the stroke.

Because Swash Block has such a strong sense of movement, practice it in its slanted Italic form. (If you prefer more equilibrium & immobility, do not slant any of the letters.)

SWASH BLOCK

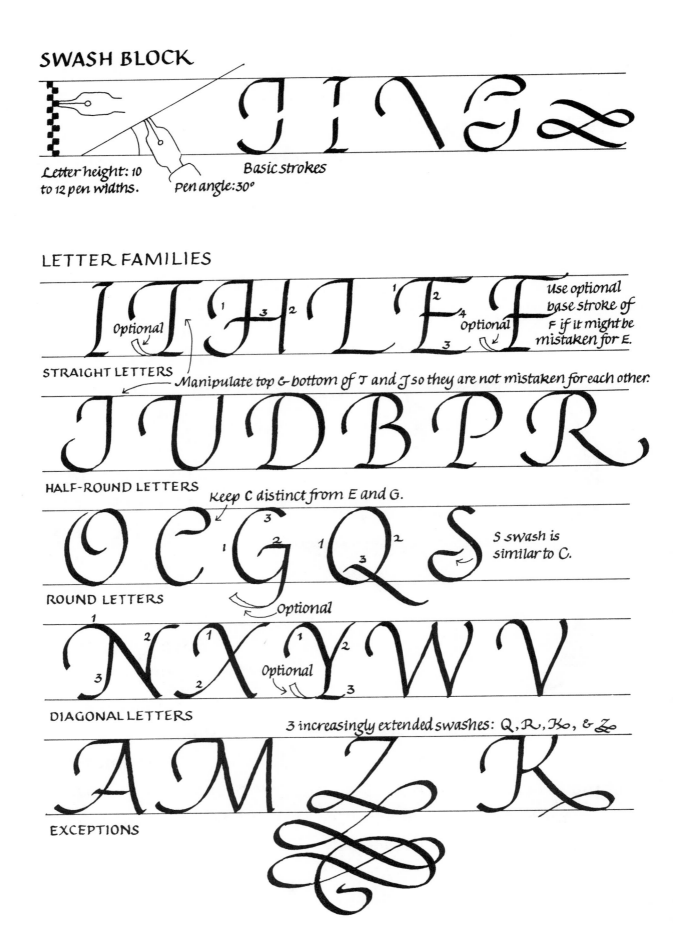

Letter height: 10
to 12 pen widths.

Pen angle: 30°

Basic strokes

LETTER FAMILIES

Optional

Use optional
base stroke of
F if it might be
mistaken for E.

STRAIGHT LETTERS

Manipulate top & bottom of I and J so they are not mistaken for each other.

HALF-ROUND LETTERS

Keep C distinct from E and G.

S swash is
similar to C.

ROUND LETTERS

Optional

Optional

DIAGONAL LETTERS

3 increasingly extended swashes: Q, R, K, & Z

EXCEPTIONS

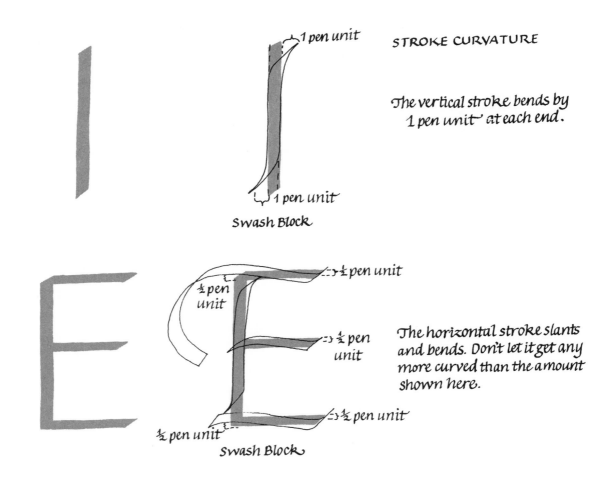

STROKE CURVATURE

1 pen unit

The vertical stroke bends by
1 pen unit at each end.

1 pen unit

Swash Block

½ pen unit

½ pen
unit

½ pen
unit

The horizontal stroke slants
and bends. Don't let it get any
more curved than the amount
shown here.

½ pen unit

½ pen unit

Swash Block

 The curves of Swash Block are so graceful
and natural that you cannot simply tack them onto the straight,
disciplined letter bodies of Block Italic. Some of the straight strokes
must curve slightly to harmonize with the swashes; they must not
curve too much, or they will compete with the swashes, reduc-
ing legibility to a mass of undifferentiated wavy lines. FOR a
general rule of thumb, bend the vertical line at each end by about
one whole pen unit, slant and curve the horizontal line by about
one-half pen unit, returning to the original stroke path.

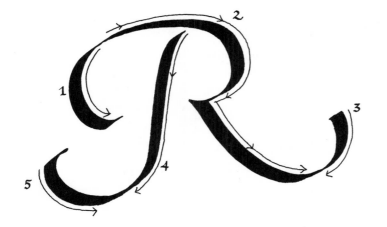

STROKE DIRECTION

If all strokes are pulled, this becomes a 5-stroke letter.

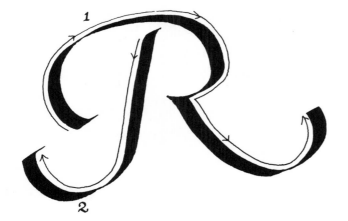

If strokes are pulled and pushed, this becomes a 2-stroke letter.

Whether to push or pull the swash strokes is up to you; if the letter is large, the text formal, the pen rough, the paper soft, and the weather damp, you may be unable to push any strokes & will have to pull each one separately, lifting the pen between each stroke segment and the next. On the other hand, if these conditions are favorable, pulling and pushing the stroke in one motion will make a much more natural letter and a more enjoyable lettering experience. Therefore, practice letters at medium size on a smooth paper with a marker or other free-flowing, snag-proof pen.

More than anything else you can do with a pen, a well-made swash sets calligraphy above the limits of all other techniques. Not handset type, rubber stamps, pressure-sensitive rub-on letters, photo-type, stencils, or computer graphics can catch a viewer's eye with the élan of a swash that fits the letter, suits the text, & harmonizes with the layout. Impressing people with swashes is like shooting fish in a barrel. Just don't overdo it; the more swashes you use, the less impact each one has.

YOU CAN CLOSE YOUR EYES TO REALITY BUT NOT TO MEMORIES.

lec

RESTFUL

Use Swash Block one or two letters at a time in initials, logos, and monograms. Mix it with plain Block Italic for sustained passages. When in doubt, leave it out; limit swashes to the beginning and end of words, lines, or paragraphs.

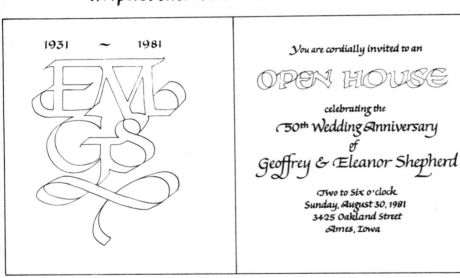

1931 ~ 1981

You are cordially invited to an

OPEN HOUSE

celebrating the
50th Wedding Anniversary
of
Geoffrey & Eleanor Shepherd

Two to Six o'clock
Sunday, August 30, 1981
3425 Oakland Street
Ames, Iowa

BONUS ALPHABET

A heavy version of Swash Block.

ABCDEFGHIJK
LMNOPQRSTUVWXYZ

SKATED BLOCK introduces a whole new dimension — literally— to your writing. Until now, you have kept the flat end of the broad-edged pen firmly in contact with the page, making the stroke widen and narrow as you changed the direction of the stroke. Now you can make the stroke get thin and stay thin, regardless of its direction, by rotating the pen up onto one corner of the flat nib and skating along on a thin thread of ink. (It sounds tricky but is in fact simple.) The calligrapher who masters this technique can intermingle broad-pen strokes with thin-pen strokes, fluently and naturally, almost as if several pens were at work at the same time. The predictable geometries of the broad nib can be tempered with the delicacy of the pointed pen.

Practice at first with a marker or a "witch pen" (Materials, page 8), which allows ink to flow easily to the corners of the nib. Try the eight basic strokes shown here; then combine them with the alphabet's upright Block Italic letter framework.

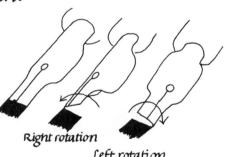

Right rotation

Left rotation

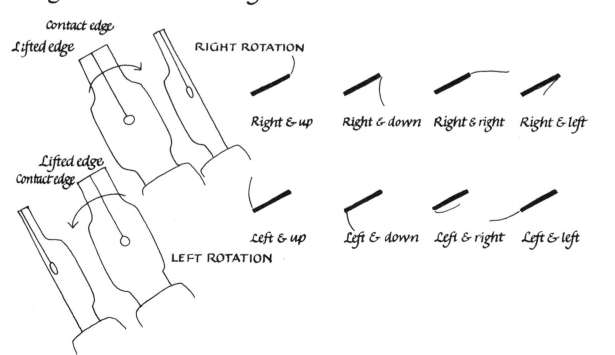

Contact edge
Lifted edge

RIGHT ROTATION

Right & up Right & down Right & right Right & left

Lifted edge
Contact edge

LEFT ROTATION

Left & up Left & down Left & right Left & left

SKATED BLOCK

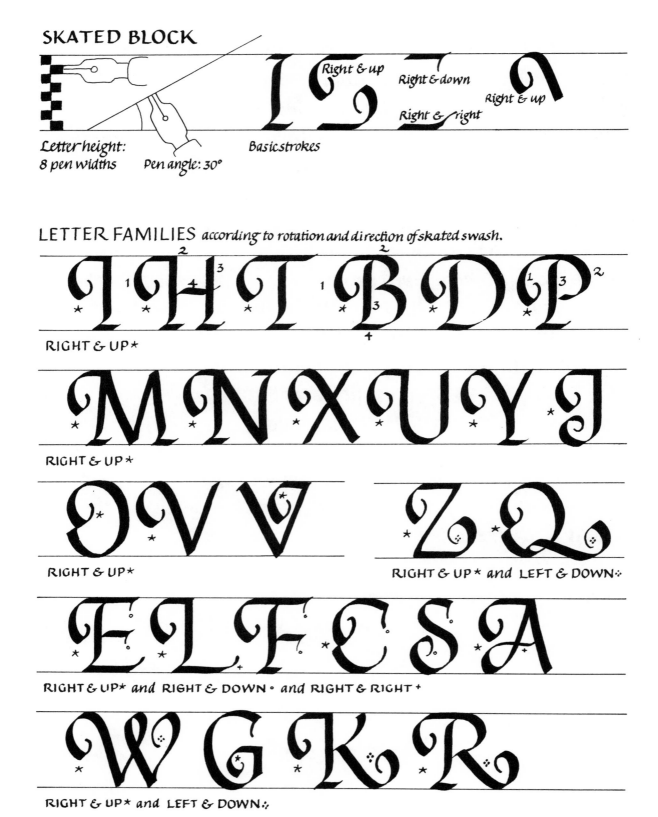

Right & up
Right & down
Right & up
Right & right

Letter height:
8 pen widths Pen angle: 30° Basic strokes

LETTER FAMILIES *according to rotation and direction of skated swash.*

I H T B D P

RIGHT & UP *

M N X U Y J

RIGHT & UP *

O V V Z Q

RIGHT & UP * RIGHT & UP * and LEFT & DOWN ∴

E L F C S A

RIGHT & UP * and RIGHT & DOWN • and RIGHT & RIGHT +

W G K R

RIGHT & UP * and LEFT & DOWN ∴

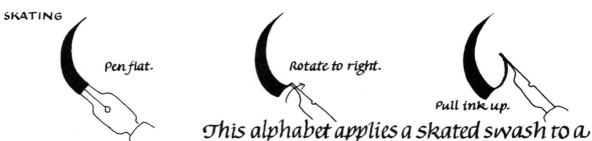

SKATING

Pen flat.

Rotate to right.

Pull ink up.

This alphabet applies a skated swash to a Basic Block letter in a controlled, uniform manner while lightening up some corner joins and adding a few serifs. The broad-edged nib is kept in contact with the paper throughout the letter body & half the swash and then rotated rather abruptly to form the second, thinner curve of the swash. By severely limiting this style to one main swash shape plus a sprinkling of two or three others, you can unify the different letters of the alphabet. Later, you can experiment with a wider range of spontaneous, individualized skated strokes and an unlimited variety of swashes.

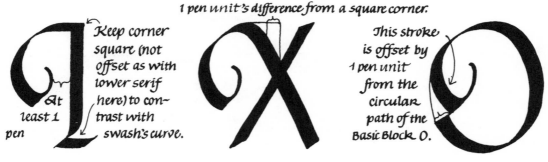

1 pen unit's difference from a square corner.

Keep corner square (not offset as with lower serif here) to contrast with swash's curve.

At least 1 pen

This stroke is offset by 1 pen unit from the circular path of the Basic Block O.

THE SKATED SWASH on 3 main letter types.

Nine out of ten swashes in this alphabet will follow the basic path shown here. The left half is skated right & up while the right stroke will either form a square corner with a vertical letter, curve down into the thick stroke of a diagonal letter, or circle around to make the right side of a round letter. Look for this recurring swash stroke and keep it uniform.

1. Center-slit metal pen 2. Off-center-slit quill 3. Square-cut brush 4. Marker, thick-cut

Each kind of pen (above) offers a distinctive shape of skated line. Center-slit metal nibs (1) give sharp, graven, but unpredictable contours, and often produce a line that is ragged on the lifted side & smooth on the contact side. (An off-center slit, possible with the hand-cut quill or reed (2) puts the ink supply near the edge of the nib.) A broad-edged brush (3) permits smooth, fluid transitions and a variable line width. While a marker (4) is inflexible (and its ink is relatively impermanent) both its width and its thickness can easily be trimmed with a sharp blade to the exact size you need for the swash and the skated stroke.

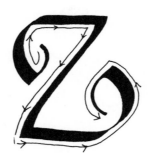

Letter & swashes without skating One continuous motion with pen. All strokes pulled with lifts between.

A center-slit nib will skate more readily if a bit of wet ink is already on the page. Thus, a swash that a marker could do in one motion may take a metal pen two or more separate strokes, in order to avoid the possibility of a snag or a dry-up. So, while some letters on the Master Sheet are shown with the numbers that suggest stroke order, your pen is the final judge of what works.

I
am the owner
of the year,
of the seven stars
and the solar
year.

RALPH
WALDO
EMERSON

A skated swash combined with Block Minus forms the oval border here.

skating has particular
impact when your pen
is relatively heavy for
the letter style, so that
there is a striking con-
trast between the thick
main strokes and the
extremely light and
unvarying thin lines.

Greater Box Bug Club

HONORARY
MEMBERSHIP

is hereby granted to

MARGO DEVANER

skating combines so
easily with the styles
you have encountered
in this book, that you
can use it just about
anywhere. It modifies
the stroke itself, the ends
of the stroke, & the join
with a second stroke—
and creates thousands
of new swashes. The
occasional physical
problems between pen
and paper (see page 91)
are all that can stand
in the way of integrating
this technique into all
your calligraphy.

HAPPY BIRTHDAY

BONUS ALPHABET
*Make small loops with one
corner of the pen.*

ABCDEFGHIJK
LMNOPQRSTUVWXYZ

TURNED BLOCK takes the specialized technique of skating (pages 87-92) and transforms it into a universally useful pen motion that can add subtlety and depth to any alphabet. This motion is the rotation of the pen between thumb and fingers. In the usual writing position, where the pen rests on the soft tissue between the base of the thumb and the first knuckle, this turns the pen nib onto one corner, changing the thick and thin line to a thin scratch. If, however, you raise the elevation of the pen so that its shaft sticks straight up off the paper like a flagpole out of the ground, & then rotate the pen between thumb & fingers, you can manipulate the thickness of the pen stroke at will. You can make thick strokes thinner and thin strokes thicker regardless of conventional pen angle & stroke direction.

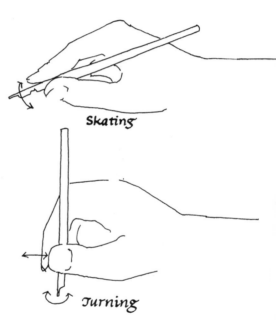

Skating

Turning

 Pen size is a key factor determining the physical ease of writing & the visual impact of this alphabet. The larger the pen, the easier it is for the eye to see where the turn of the pen has altered the stroke contour.

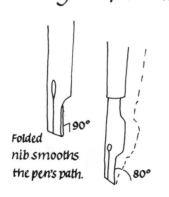

Folded nib smooths the pen's path.

90°

80°

If metal nib snags, reduce pen elevation slightly.

 Another important consideration is the kind of broad-edged pen you choose. (See page **8.**) A marker (best) or metal pen with nib folded at the end facilitates a smooth flow of ink when the pen is properly elevated. A sharp metal nib may make you lower the elevation to sustain the ink flow, a position that necessitates arm, as well as finger, movement to turn the pen.

TURNED BLOCK

Letter height: 6
to 8 pen widths.

Basic strokes
Pen angle will vary between 0° and almost 90°
depending on how thick you want the stroke
and what shape you want the stroke ends.

LETTER FAMILIES

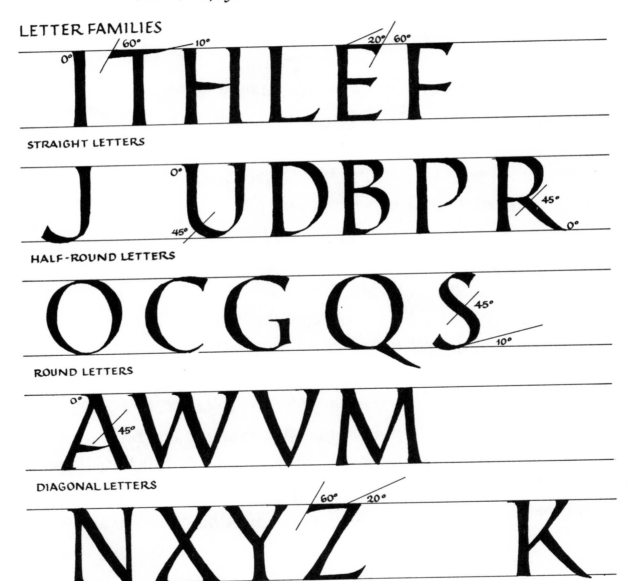

STRAIGHT LETTERS

HALF-ROUND LETTERS

ROUND LETTERS

DIAGONAL LETTERS

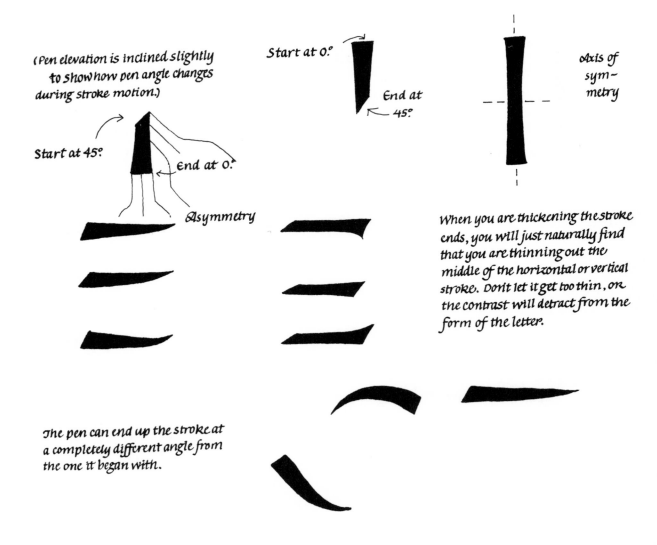

(Pen elevation is inclined slightly to show how pen angle changes during stroke motion.)

Start at 0.°

End at 45°

Axis of symmetry

Start at 45°

End at 0.°

Asymmetry

When you are thickening the stroke ends, you will just naturally find that you are thinning out the middle of the horizontal or vertical stroke. Don't let it get too thin, or the contrast will detract from the form of the letter.

The pen can end up the stroke at a completely different angle from the one it began with.

The simplest movement in pen turning is widening the ends of the stroke and narrowing its center, to make a serif that grows organically out of the stroke instead of being added to it with a separate stroke. Both vertical and horizontal*straight strokes can be widened at one or both ends.

Some widened stroke ends will be symmetrical, as with the vertical of T or H; others, like the horizontals of T & E, will widen asymmetrically and at one end only.

★ and the near-horizontal top & bottom curves of S, G, and C.

Basic Block

E

*Turning helps to thin out
straight letter joins.*

Turned Block

*With corner joins on diagonal
letters, you can choose from two
design options. Either sharpen
the corner to a point, as in the
central V of the M; or widen it
out, shaping a flat serif ending,
as in the upper corners of the M.*

*Note how turning shifts the
weight of a curved stroke.*

Basic Block Turned Block

Thickening the ends of the strokes necessitates thinning out the joins to keep the alphabet from getting too heavy. This is particularly useful with the diagonal letters, where sharply pointed corners can be fashioned.

Curved letter joins can also be subtly thinned out, which will lighten the whole curve slightly and make its transition from thin to thick a little more compressed and dramatic. The tight curves and heavy overlaps of B, P, and R can be gracefully lightened, and the impossible U-join made possible.

Turned letters can be used anywhere, depending on the amount of turning you choose to do. Subtle adjustments can soften Basic Block, neaten its joins, & shape its serifs, without changing its underlying architecture. More pronounced turning, where hairlines swell to wide strokes in unexpected places, are more startling; this kind of alphabet is better suited to artistic pieces, short sentences or single words, and abstract letter designs where easy legibility is not of primary importance. Do not neglect the basic letter structure. No amount of pen turning can rescue bad proportions.

RSVP

BLESSED
ARE THE
PEACE —
MAKERS.

since pen turning gets easier and looks better the larger the letter, do banners, giant posters, & classroom examples with a flat housepainter's brush.

BONUS ALPHABET
A split pen or marker highlights the structure of turned strokes.

ABCDEFGHIJK
LMNOPQRSTUVWXYZ

SMALL LETTERS

blockhand, like its capitalized relative Basic Block, is so bald and unadorned that many calligraphers cruise right past it in quest of more dressed-up alphabets. Yet these basic letters are triply essential to the calligrapher: first, as a pure and rigorous exercise in calligraphic proportions; second, as a simple and transparent style for the communication of many kinds of text; third, as the framework on which are built most lower-case alphabets of the last 1000 years. With all this in mind, you should approach Blockhand as the core of the small-letter styles set out in the following chapters.

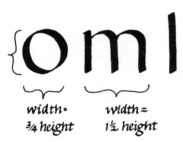

width=
¾ height

width =
1½ height

Blockhand, like Basic Block, is constructed on a letter body taller than its width. N, B, X, and S, for instance, are the same width. L and I, of course, are one pen unit wide, while M and W are of necessity wider than the O.

All the extenders are half again the height of the letter body. When Blockhand is combined with Basic Block, the ascenders will extend one pen width higher than the capital. This keeps the capital from dwarfing the small letters and vice versa.

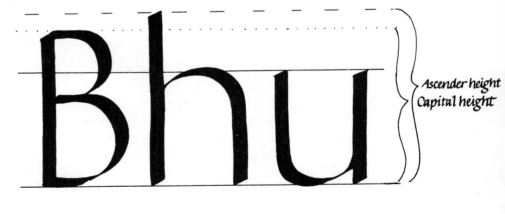

Ascender height
Capital height

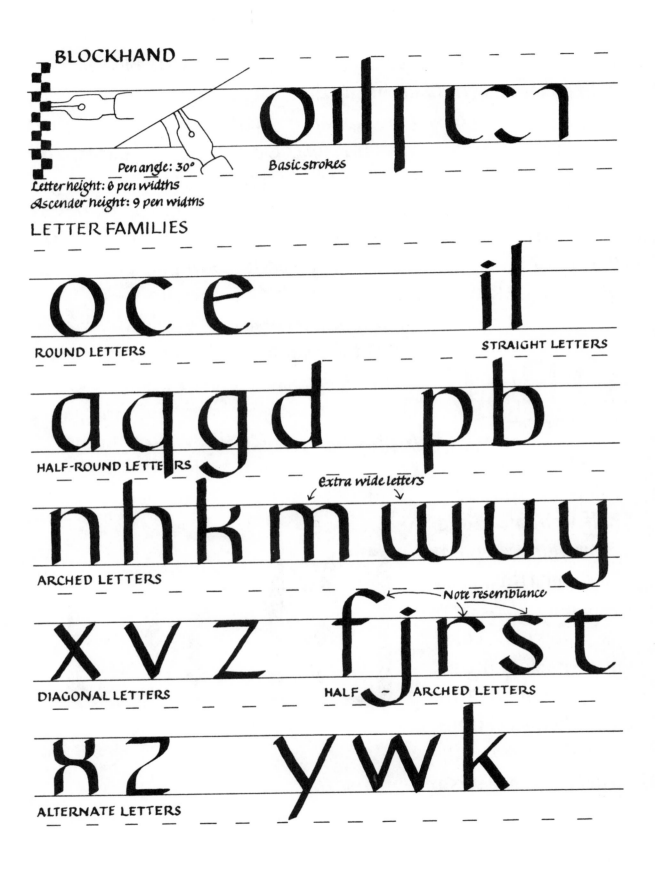

BLOCKHAND

Pen angle: 30°

Basic strokes

Letter height: 6 pen widths
Ascender height: 9 pen widths

LETTER FAMILIES

o c e

ROUND LETTERS

i l

STRAIGHT LETTERS

a q g d

HALF-ROUND LETTERS

p b

Extra wide letters

n h k m w u y

ARCHED LETTERS

Note resemblance

x v z

DIAGONAL LETTERS

f j r s t

HALF - ARCHED LETTERS

ꝗ z

ALTERNATE LETTERS

y w k

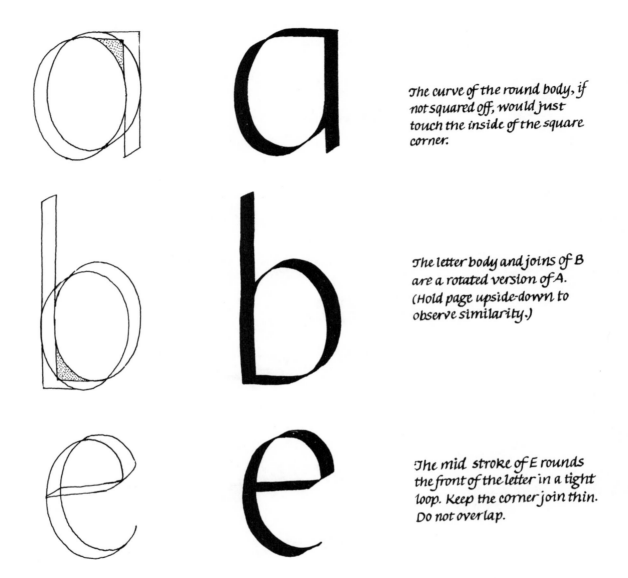

The curve of the round body, if not squared off, would just touch the inside of the square corner.

The letter body and joins of B are a rotated version of A. (Hold page upside-down to observe similarity.)

The mid stroke of E rounds the front of the letter in a tight loop. Keep the corner join thin. Do not overlap.

One of Blockhand's central tasks is the joining of round strokes to straight strokes. Study the two kinds of half-round letters shown above, noting where the corners are rounded and where they are split.

The straight line across the middle of the E introduces a special curve and join into the visual vocabulary of Blockhand. Don't make the loop too small.

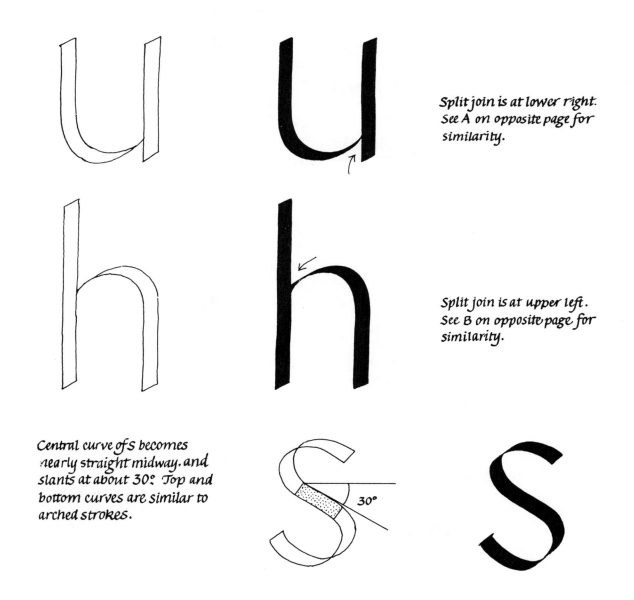

Split join is at lower right.
See A on opposite page for
similarity.

Split join is at upper left.
See B on opposite page for
similarity.

Central curve of S becomes
nearly straight midway. and
slants at about 30°. Top and
bottom curves are similar to
arched strokes.

30°

 Two kinds of arched letters join curves to straight
strokes, either at top or at bottom, leaving the other end open. Both are
split joins that resemble the joins at lower right of A, G, Q, & D, and
upper left of P and B.

 Practice S repeatedly to get the slope of the cen-
ter stroke angled correctly. Top and bottom of S are identical with top
of F and R, and bottom of J, G, and Y.

Success in your work, the finding a better method, the better understanding that insures the better performing, is hat & coat, food and wine, is fire and horse & health & holiday.

Ralph Waldo Emerson

Blockhand seems to work best for sentences or whole paragraphs of text rather than a few isolated words or letters. It has more affinity for prose than poetry, and unless you wish to copy each line twice to get the spacing right, it usually will arrange itself most naturally into a "ragged-right" layout.

Because so much of the Blockhand alphabet's value lies not just in its immediate utility as a text letter but also in its adaptability to other styles, this chapter offers nine new alphabets derived from the Basic Block variations and their bonus alphabets set out in the first section of this book.

Bitter are the tears of a child:
Sweeten them.
Deep are the thoughts of a child:
Quiet them.
Sharp is the grief of a child:
Take it from him.
Soft is the heart of a child:
Do not harden it.

Lady Pamela Wyndham Glenconner

a b c d e f g h
i j k l m n o p q
r s t u v w x y z

Light Blockhand

**Blockhand
Chip-Off Serif**

abcdefgh
ijklmnopq
rstuvwxyz

Blockhand Serif

abcdefgh
ijklmnopq
rstuvwxyz

Blockhand Off-Hand

abcdefgh
ijklmnopq
rstuvwxyz

Blockhand Minus

abcdefgh
ijklmnopq
rstuvwxyz

Skated Blockhand

abcdefgh
ijklmnopq
rstuvwxyz

Turned Blockhand

abcdefgh
ijklmnopq
rstuvwxyz

Double Blockhand

abcdefgh
ijklmnopq
rstuvwxyz

Deco Blockhand

abcdefgh
ijklmnopq
rstuvwxyz

gothic hand compresses and regularizes the Blockhand alphabet to make an appealing style with a strong accent on the vertical. Although the basic letter stroke bends at the ends to form joins or serifs, it is straight in the middle. The letter itself is narrower than Blockhand by two pen units, bringing its width to about half its height. To visualize this, think of the basic round letter being pushed by upright straight edges from either side, so that the curves flatten out while the top remains arched.

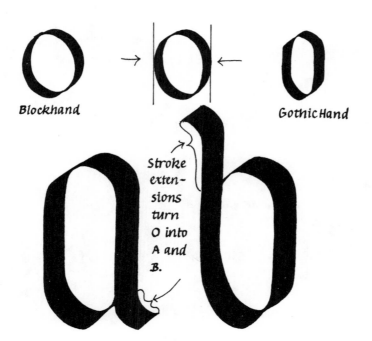

Blockhand

Gothic Hand

Stroke extensions turn O into A and B.

Over half the letters in this alphabet are based on two letter shapes — which are in fact just upside-down versions of each other — the A-body & the B-body. Both these shapes, in turn, differ from the fundamental O-shape by one part of one stroke.

Gothic Hand letters are almost all one uniform width. Only M and W exceed this; L, I, J, and J are half its width.

Note stroke regularity.

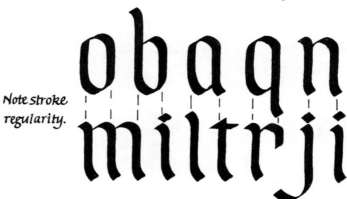

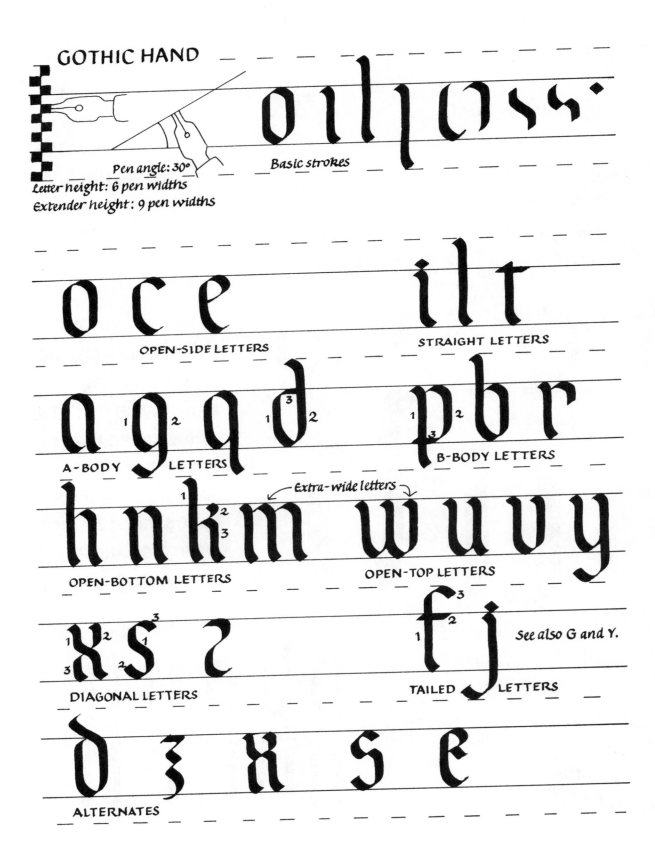

GOTHIC HAND

Pen angle: 30°
Letter height: 6 pen widths
Extender height: 9 pen widths

Basic strokes

OPEN-SIDE LETTERS

STRAIGHT LETTERS

A-BODY LETTERS

B-BODY LETTERS

OPEN-BOTTOM LETTERS

Extra-wide letters

OPEN-TOP LETTERS

DIAGONAL LETTERS

TAILED LETTERS

See also G and Y.

ALTERNATES

Blockhand
(outline)

6 pen units

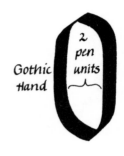

Gothic
Hand

2
pen
units

Iterior space equals
exterior space.

nnn

This space = this space

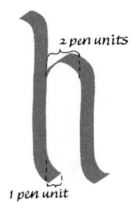

2 pen units

1 pen unit

Pay attention to proportion, to help keep this alphabet from becoming vague and mushy. First, to get the height-to-width ratio correct, visualize the Gothic Hand letter fitting precisely into the space inside the Blockhand letter; this compressed letter will be about two pen·units wide <u>inside</u>. Second, when writing words, be sure to make the space inside the letters equal to the space between letters. Third, a serif extends one pen unit to the left or right of the main stroke. A curve extends two pen units, to join the thinnest part of its stroke to the thinnest part of another, or to intersect a vertical stroke.

Above and below the diagonal, s resembles O.

x and S share a special diagonal middle stroke.

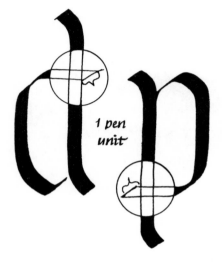

D & P are rotated versions of each other. The special flat stroke solves the problem of keeping this join light and uncluttered.

1 pen unit

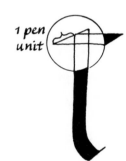

1 pen unit

Keep this triangular inter-section solid by allowing only 1 pen unit above and left of main stroke.

Beyond the nucleus of A- and B-based letters lie a number of special cases, which require additional strokes, or special treatment of standard strokes, for their construction. A short, smoothly joined stroke bridges the diagonal center sections of X & S. The flat crosspiece of F & T is used also to reconcile the shapes of D and P with the visual necessity to avoid heavy joins. Other letters, plus the many alternate forms, reassemble the basic letter strokes in new ways, like spare parts borrowed from one mechanism ⌐to make another.

Church Supper
6:00, 1st seating; 7:00, 2nd seating
Wednesdays, in
the Community
Activities Room.

Gothic Hand has a split personality; the same letters can appear pure, clean, and modern, or medieval, ecclesiastical, and ornate, depending on layout and content. Use them both ways.

Gothic Hand letters not only compress more words into the same length of line than either Blockhand or Italic Hand, but the basic letter shape itself accentuates the vertical line in your layout. To keep a piece of Gothic Hand calligraphy from getting too tall & spindly, introduce & emphasize some horizontal lines to counterbalance all those vertical ones.

Born in Lincolnshire, England about 1590
Richard Bellingham
died in Boston, Massachusetts 7 Decemb
Winning favor by
1672. An Uncompromising Puritan. A
Incorruptible devotion
member of the Company to which was
Common Welfare &
granted the Charter of the Massachuse
Consistent Hostility
Bay Colony. He migrated to New
Autocracy. He lived
England 1634 and served the Colony
Honorably and died
as Treasurer, Deputy Governor and
Honored. A true
Governor. Learned in the Laws of Eng
New England Man.
land. Slow of speech, difficult

Light Gothic Hand

a b c d e f g h
i j k l m n o p q
r s t u v w x y z

Gothic Hand Plus

a b c d e f g h
i j k l m n o p q
r s t u v w x y z

Split Gothic Hand

a b c d e f g h
i j k l m n o p q
r s t u v w x y z

Skated Gothic Hand

a b c d e f g h
i j k l m n o p q
r s t u v w x y z

Double Gothic Hand

a b c d e f g h
i j k l m n o p q
r s t u v w x y z

abcdefgh
ijklmnopq
rstuvwxyz

Heavy Gothic Hand

abcdefgh
ijklmnopq
rstuvwxyz

*Gothic Hand
Minus*

abcdefgh
ijklmnopq
rstuvwxyz

*Squeezed
Gothic Hand*

italic hand lies somewhere between Blockhand and the Italic cursive in which this book is lettered. Its slant gives it expressiveness, while its careful construction maintains its formality.

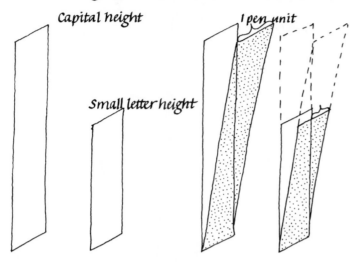

Capital height

Small letter height

Basic Block Blockhand Block Italic Italic Hand

As with Block Italic, the amount of slant is important. If the capital, which is just a little under twice the height of the small letter, slants by one pen unit, then the small letter, at a little over one half its height, should slant about one-half pen unit.

Even more crucial than the slant is the location of the join between the curved (& arched) and straight strokes. It is farther from the end of the straight stroke than the join in Blockhand. A third distinguishing characteristic of this letter is the small sideways serif stroke at the unjoined stroke ends.

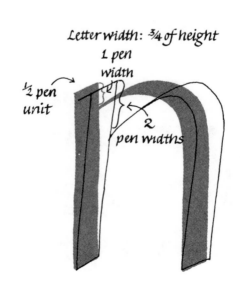

Letter width: ¾ of height

1 pen width

½ pen unit

2 pen widths

LETTER SLANT

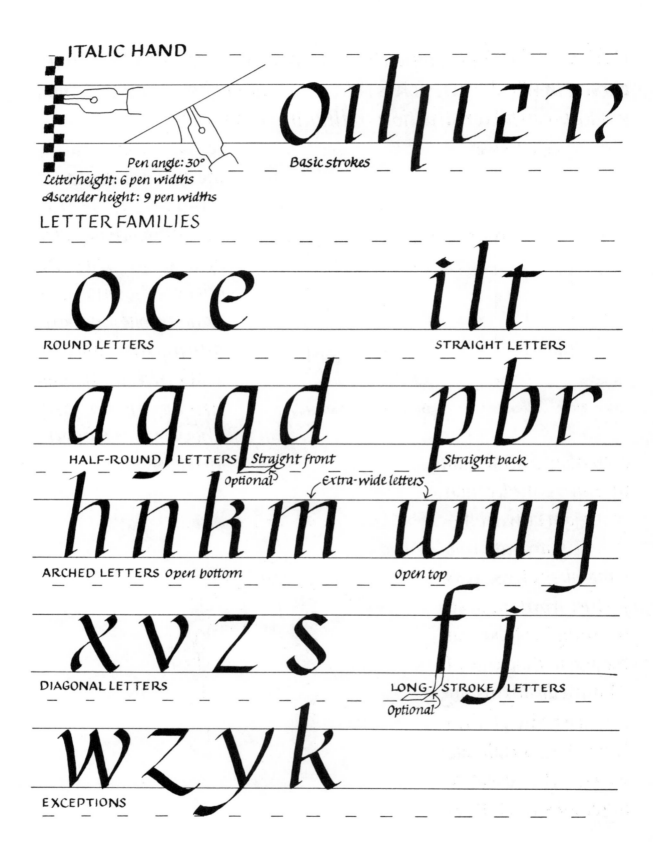

ITALIC HAND

Pen angle: 30° Basic strokes
Letter height: 6 pen widths
Ascender height: 9 pen widths

LETTER FAMILIES

o c e i l t

ROUND LETTERS STRAIGHT LETTERS

a g q d p b r

HALF-ROUND LETTERS Straight front Straight back
 Optional Extra-wide letters

h n k m w u y

ARCHED LETTERS Open bottom Open top

x v z s f j

DIAGONAL LETTERS LONG-STROKE LETTERS
 Optional

w z y k

EXCEPTIONS

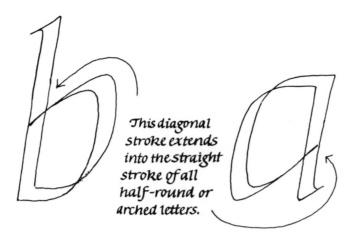

This diagonal stroke extends into the straight stroke of all half-round or arched letters.

A or B BODY LETTERS

Invert page to see relationship of A and B letter bodies.

In the upper right corner of A, G, and Q, and the lower left corner of B, these two strokes just touch.

In D and P it overlaps the upright stroke.

A or B body letters foster letter families with strong family resemblances.

To keep partial letters accurate, complete the omitted sections in your mind's eye.

Over half of the Italic Hand letters, both half-round and arched, follow the basic letter shape of A or B. The A & B letter bodies, in addition, are simply upside-down versions of each other, so that you are in reality dealing with only one basic shape of letter body, to which you add strokes or from which you delete strokes. This fosters a strong sense of internal stylistic unity within the alphabet.

If you have trouble dovetailing the strokes of K, picture the top of an H arch, but lower. Then add a short diagonal stroke.

The lower curve of J is almost straight, following the path of the lower right corner of B. Similarly, the top of F follows the top of A.

Other letters have their own individual logic, which each calligrapher must pursue.

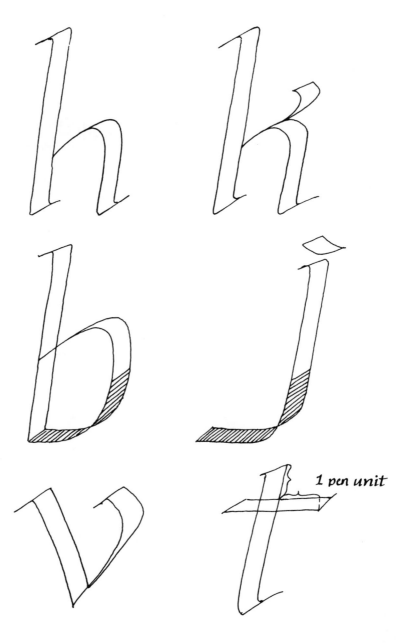

1 pen unit

Italic Hand letters that are not built upon the basic A or B letter body may still borrow parts of it to use together with other strokes. Even the diagonal and nonstandard letters echo the basic letter body in their proportions, curves, and joins. Keep a family resemblance throughout the letters of this alphabet.'

Italic Hand lends itself to everything from a handwritten thank-you note to a Shakespearean sonnet. Use it wherever your own handwriting would be too casual or Blockhand calligraphy too formal. It mixes well with the upright Blockhand styles, however; either in paragraphs to denote a new speaker or tone of voice, or one at a time for emphasis.

You must do the thing you think you cannot do.

Eleanor Roosevelt

Youth pro Musica

Presented by the Board of Directors & Staff
of Youth pro Musica
with thanks
to

Samuel B. Bruskin, Esq.

whose patient guidance, faithful support, and
generous professional service have
gained for him the high regard and affection
of his fellow board members.

Do not confuse Italic Hand with Italic, where letter joins are different; compare these 2 passages written in the 2 styles.

Do not confuse Italic Hand with Italic, where letter joins are different; compare these 2 passages written in the 2 styles.

Light Swashed Italic Hand

a b c d e f g h
i j k l m n o p q
r s t u v w x y z

Italic Hand Serif

a b c d e f g h
i j k l m n o p q
r s t u v w x y z

Heavy Italic Hand

a b c d e f g h
i j k l m n o p q
r s t u v w x y z

Skated Italic Hand

a b c d e f g h
i j k l m n o p q
r s t u v w x y z